LANCASHIRE
MOODS

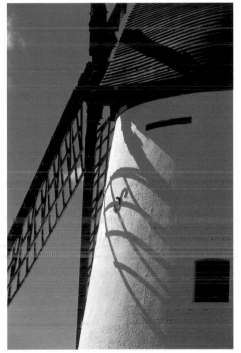

JON SPARKS

HALSGROVE

First published in Great Britain in 2005

Title page photograph: **Windmill, Lytham**

British Library Cataloguing-in-Publication Data
A CIP record for this title is available from the British Library

ISBN 1 84114 439 8

HALSGROVE
Halsgrove House
Lower Moor Way
Tiverton, Devon EX16 6SS
Tel: 01884 243242
Fax: 01884 243325
email: sales@halsgrove.com
website: www.halsgrove.com

Printed by D'Auria Industrie Grafiche Spa, Italy

INTRODUCTION

Some years ago, a friend of mine – whose first job after graduating had been in Surrey – secured a new post in Lancashire. Naturally she was delighted, much to the bafflement of friends and colleagues down south. It seemed they could not understand why she might be willing – even eager – to trade leafy suburbia for back-to-back housing overshadowed by dark Satanic mills, in a land where it rains 300 days a year and snows on most of the rest.

I exaggerate, but not all that much. The North in general, and Lancashire in particular, still has an image problem. Millions of people continue to draw their notions of what Lancashire is like mostly from *Coronation Street* – blissfully unaware that 'Corrie' is actually set in Salford, which hasn't been part of Lancashire for over thirty years.

A more recent TV image was painted by the Sunday evening series *Born and Bred*, filmed in Downham in the Ribble Valley. Always assuming that viewers realised the series was set in Lancashire (and I have seen at least one magazine giving the credit to Yorkshire), it does at least redress the balance and show that Lancashire has a rural side. But it still goes nowhere near doing justice to the county that I know and that I have called home for most of my life.

I began my exploration, naturally, with my home patch in the northernmost part of the county. I have come to realise that in many ways this area is a microcosm of the whole, cramming the main elements of the Lancashire mix into a small space. There's an historic city, green countryside, cosy villages, and a sweep of coastline, all overlooked by high, lonely moors.

Over time, various interests led me to explore more of the county. Cycling, sometimes long distances, took me down flowery lanes and up onto the roads over the ridges, where the effort of the climb is rewarded first with a tremendous view and then with an exhilarating descent. Rock-climbing took me into some unexpected places: Lancashire's quarries boast literally thousands of climbing routes. In a professional capacity I have subsequently produced guidebooks for both cyclists and walkers, and have also photographed in every part of Lancashire. As time goes on I am more, not less, impressed by the county's diversity and its capacity to surprise.

To distil this diversity into a sentence or two is manifestly impossible. You can make a stab at it by saying that Lancashire is flat in the west and hilly in the east. Most of the industrial towns on which the stereotype is based are concentrated in a narrow band along the margins of the uplands, where abundant water-power drove the early stages of the Industrial Revolution before the coming of steam. The

lowlands of the west, previously wet and inhospitable, were progressively drained and turned into farmland to feed the growing towns. For the workers in those towns life was undeniably grim, but freedom and clean air were found in a Sunday walk out onto the moors, and perhaps a week at one of the new resorts along the coast.

The east-west division is a gross over-simplification. The valley of the Ribble, Lancashire's major river, cuts the eastern upland into two major blocks, the West Pennines to the south and the Forest of Bowland to the north. Bowland, much more lightly impacted by industry, is bounded in turn on its northern flank by the Lune valley. The landscape of the Ribble and Lune valleys is lightyears away from the stereotype of Lancashire. Instead it is what many people think of as quintessentially English: a rumpled patchwork of green fields, hedgerows and woods, a scene that is all but extinct in large parts of southern England.

This is still a very broad-brush picture of Lancashire. There is much, much more to it. I can only hope that the pictures in the following pages will do justice to it, but I am acutely aware of all the places that have been omitted. It speaks volumes for the county that my biggest problem was not what to put in, but what to leave out.

Jon Sparks

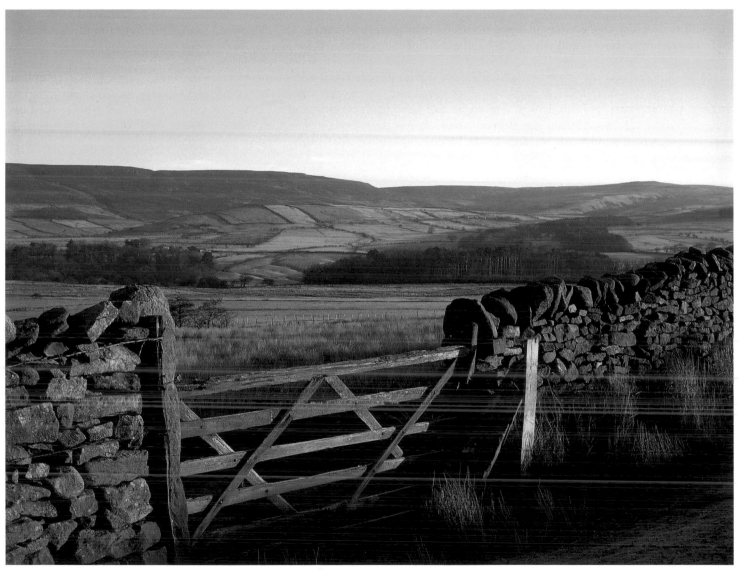

Wyresdale and the Bowland Fells
The Bowland Fells form a substantial block of high ground in the north of the county,
reaching to within 10 kilometres of the coast. The Fells and the surrounding valleys form
the Forest of Bowland Area of Outstanding Natural Beauty.

Fire Station, Singleton
The village of Singleton is in the Fylde, a short distance from Blackpool. Its most appealing building and also probably its smallest is this half-timbered structure, originally the village fire station. The first fire engine was horse-drawn and it's said that the first thing the crew had to do in response to an alarm was to catch the horse!

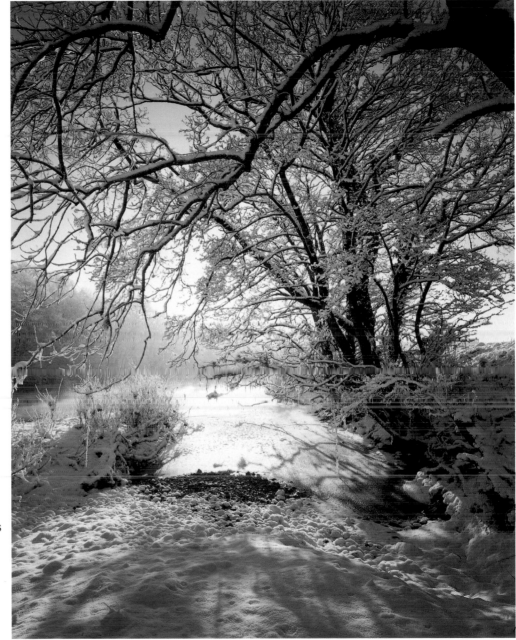

River Lune near Loyn Bridge
The Lune is the most northerly of Lancashire's major rivers and the Lune valley has some of the county's loveliest scenery. But it's a rare day when it looks like this.

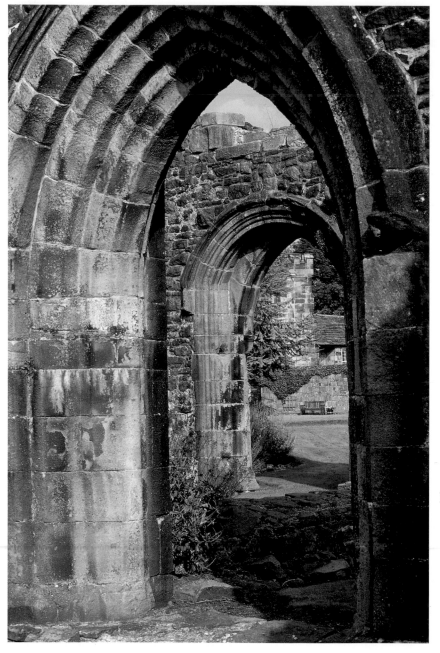

Whalley Abbey

Whalley is in the Ribble Valley, at the heart of Lancashire. Whalley Abbey was founded in 1296. The great abbey church is now an imposing ruin but the gardens are lovingly maintained. One surviving building is used by the Diocese of Blackburn for conferences and retreats.

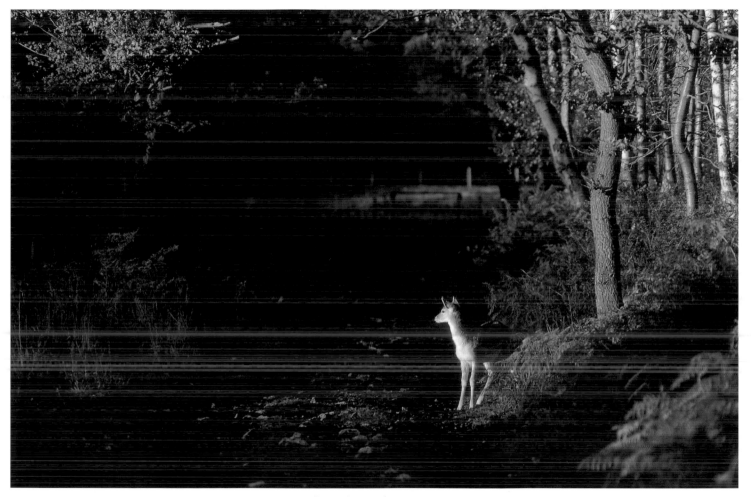

Fallow deer, Thrang Moss
Lancashire has almost exclusive ownership of the Forest of Bowland Area
of Outstanding Natural Beauty, and a half-share in the Arnside/Silverdale
AONB, which straddles the Cumbrian border. All three native species of deer
(red, roe and fallow) are regularly seen here; there's no need to sit in a
hide for hours, but the chances are best if you walk quietly.

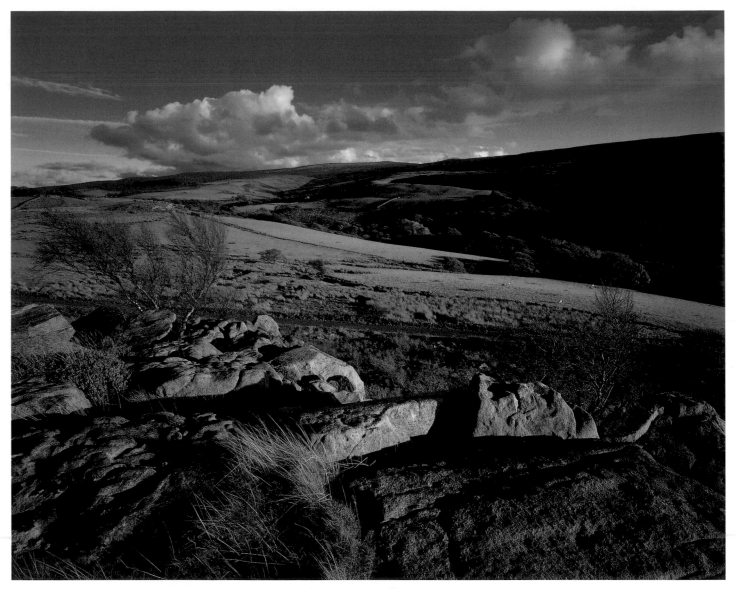

Littledale and Ward's Stone from Baines Crag
Baines Crag is only a few kilometres from Lancaster, on the edge of the Forest of
Bowland AONB. On the skyline is Ward's Stone, the highest point in the Bowland Fells
and the highest ground wholly within the county of Lancashire.

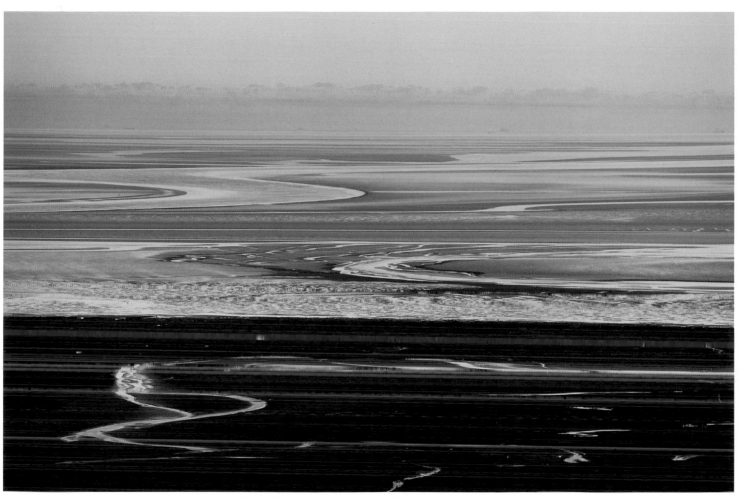

Channels, Morecambe Bay, from Warton Crag
Low tide reveals the Bay's eternally shifting maze of channels and mud-flats. It is of huge importance for wildlife, especially over-wintering birds. The sands are dangerous to the uninitiated and the crossing should never be attempted without a guide. The dangers were tragically illustrated by the disaster of February 2004, in which 23 Chinese cockle-pickers drowned.

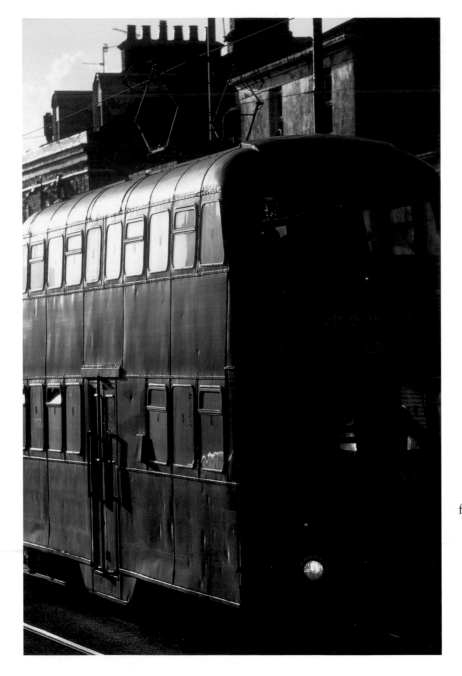

Tram in Fleetwood
Blackpool and Fleetwood could be forgiven
for saying: 'We told you so'. For several decades
theirs were the only working trams in Britain.
Recently several other towns and cities in
the country have been building new tram
networks at great expense.

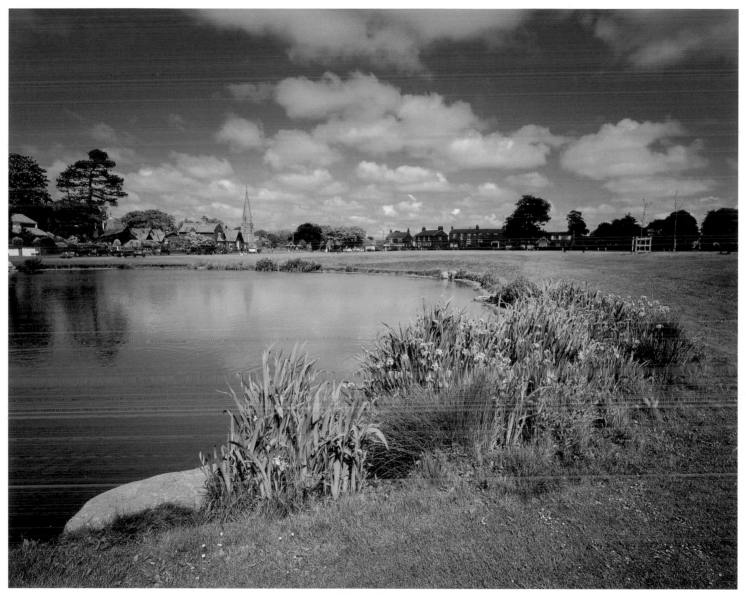

Wrea Green
Wrea Green, in the Fylde, has the largest village green in Lancashire. The village was originally called
Wray, but sportingly changed its name to reduce confusion with the other Wray, in the Lune valley.

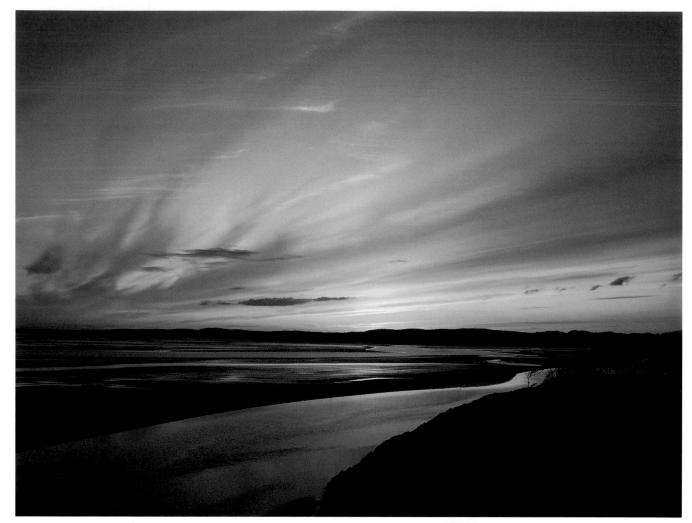

Sunset from Jack Scout, Silverdale

The cliffs of Jack Scout overlook the meeting of the Kent Estuary and Morecambe Bay, beyond which are Grange-over-Sands and the ridge of Hampsfell. The silhouette of Dow Crag and Coniston Old Man can be seen in the distance at the right of the picture. The cove below the cliffs was known as Cow's Mouth, being one of the places where cattle were brought ashore after being driven across the sands of Morecambe Bay. Cross-bay commerce ended with the coming of decent roads and then railways, but the unique experience of the Cross-Bay Walk is still enjoyed by thousands every year, in the capable hands of Cedric Robinson, the Queen's Guide to the Sands. It must be stressed that it is very dangerous to attempt the crossing without a guide.

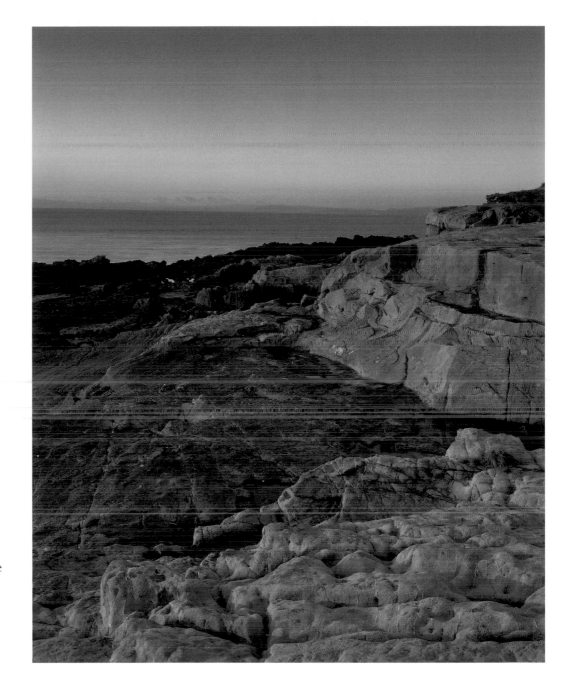

Evening, Heysham Head
Late evening light warms
the wave-worn rocks of
Heysham Head, on the edge
of Morecambe Bay.

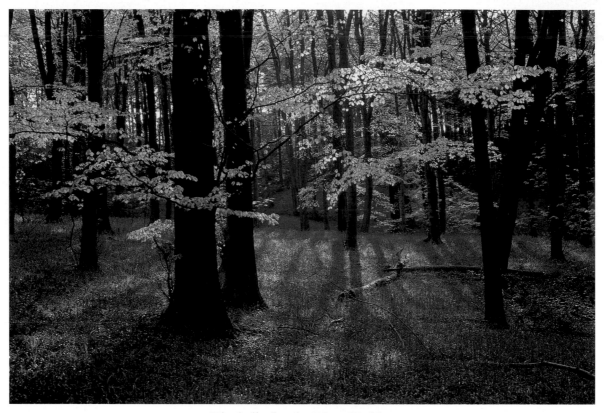

Bluebells, by the River Hodder
Bluebell woods are a British speciality and Lancashire has some of the best. This one lies
between Lower Hodder Bridge and Higher Hodder Bridge, west of Clitheroe. Footpaths follow
the west bank of the river, making a fine easy walk which can be turned into a circuit by climbing
to the excellent viewpoint of Birdy Brow and returning past Stonyhurst College.

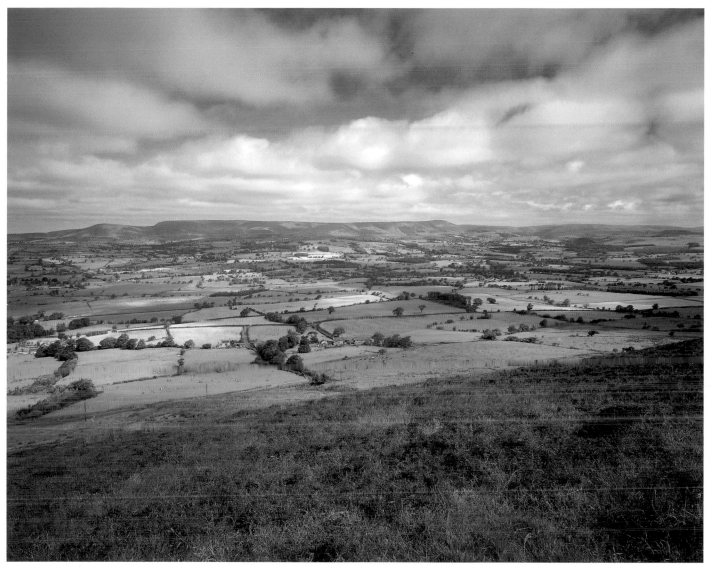

View from Jeffrey Hill, Longridge Fell
Longridge Fell is accurately named. It is a single ridge rising to 350m and standing alone with no connection to other high ground, though geologically it is part of the Forest of Bowland. From Jeffrey Hill, where a road crosses the ridge, the view stretches over the valley of the River Loud (ironically one of the quietest parts of Lancashire) to the Bowland Fells.

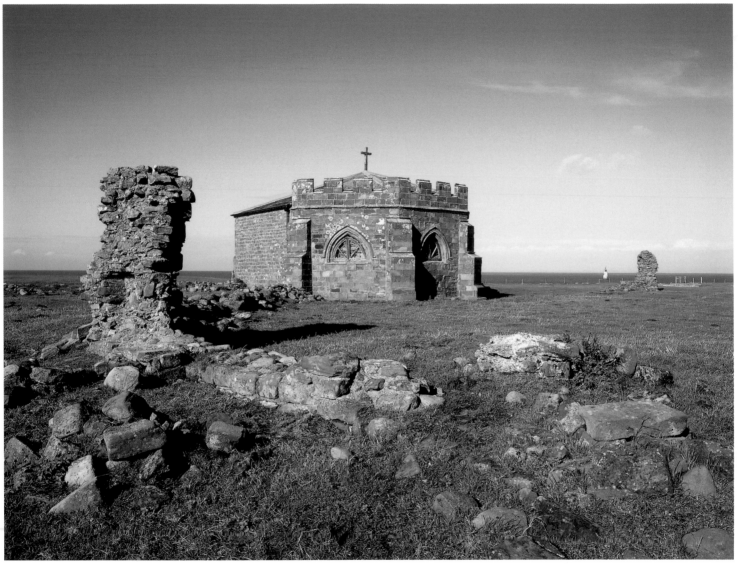

Cockersand Abbey
This is just about all that remains of Cockersand Abbey, overlooking the mouth of the
River Lune. In the twelfth century, when the first hermits came here, the site was virtually
an island, remote from worldly temptations and reasonably safe from marauders. It later
became a hospital and then a priory of the Premonstratensian order.

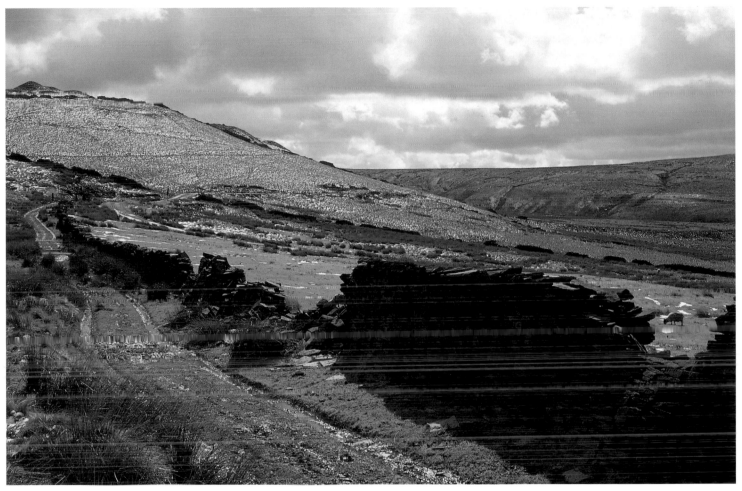

Above Rawtenstall
It seemed a fairly unpromising day on the moors above the Rossendale valley, until the sun poked through briefly and everything came together: the lines of the ancient road and wall and the fall of the light on the thin dusting of snow.

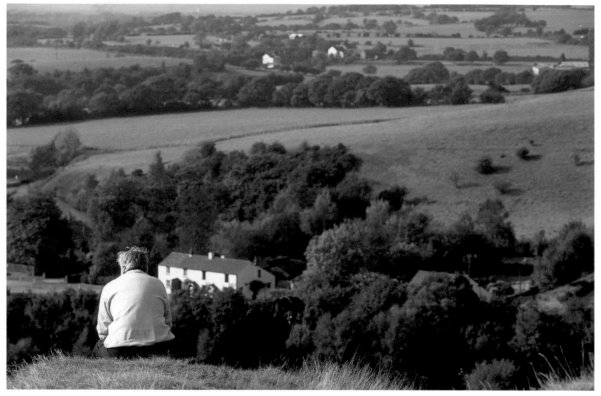

Above White Coppice
White Coppice is a tiny hamlet not far from Chorley, from where you can
climb up on to the West Pennine moors, whether for a day striding over
the tops or just to sit and admire the view.

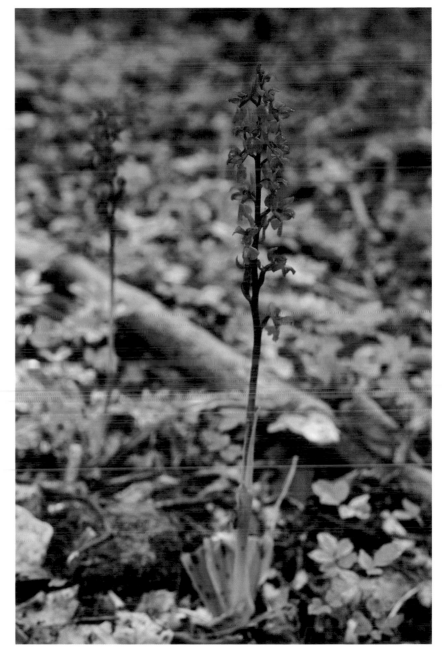

Early purple orchid, Hyning Scout Wood
Hyning Scout Wood is near to Yealand Conyers,
in the Arnside-Silverdale AONB. Early purple
orchids are a common sight in the area in spring,
and many less common species can also be found.
The wood is owned by the Woodland Trust,
a charity dedicated to preserving woods and
creating new ones, and is open to the public.

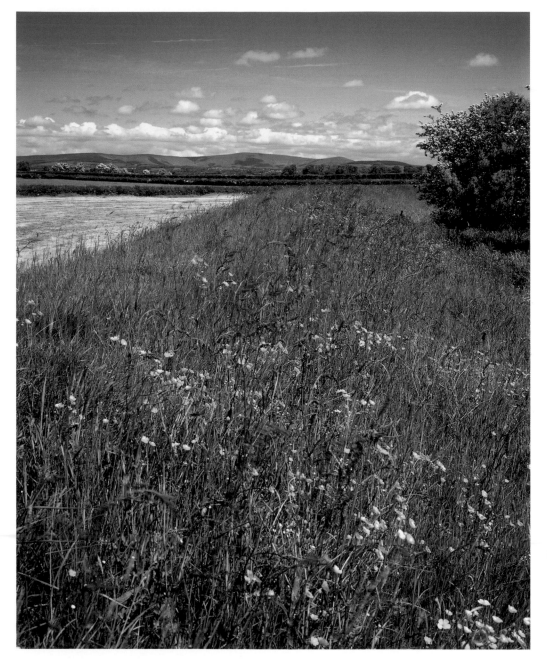

Fields near Inskip
Inskip is in the centre of the
Fylde, in one of the flattest parts
of Lancashire, and drained fields
contrast with small areas of
surviving wetland. The Bowland
Fells loom on the horizon.

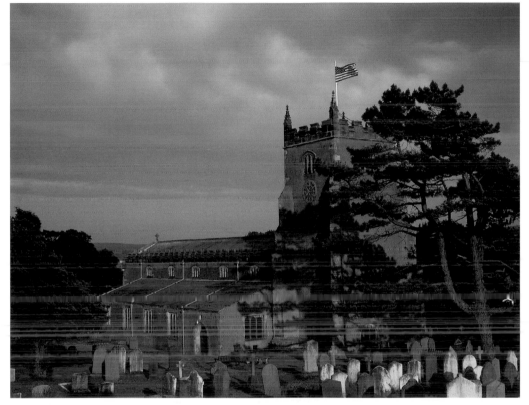

Warton church, stars and stripes
Warton, just north of Carnforth, is an attractive village, but there's a
specific reason why it draws many American visitors. St Oswald's church
has connections with the ancestors of Geroge Washington, the
first president of the US. Emblems carved on a medieval stone are thought
to have suggested the stars and stripes motif. In commemoration, the
church flies the American flag each year on the Fourth of July.

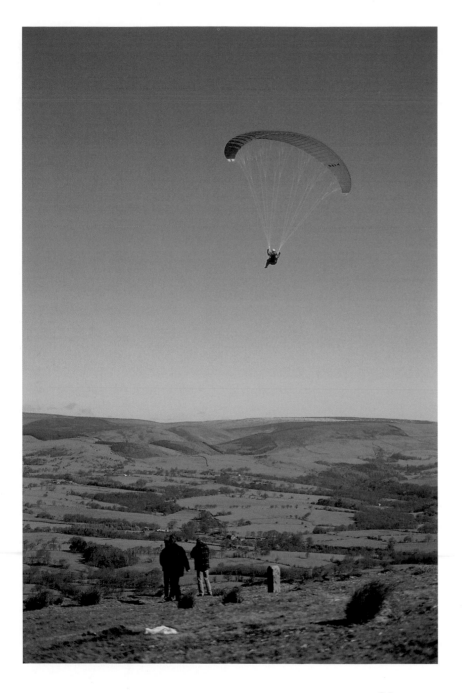

Paraglider, Jeffrey Hill
I make no excuses for including Jeffrey
Hill a second time; it's one of Lancashire's
finest viewpoints, at least among those
easily accessible by road.

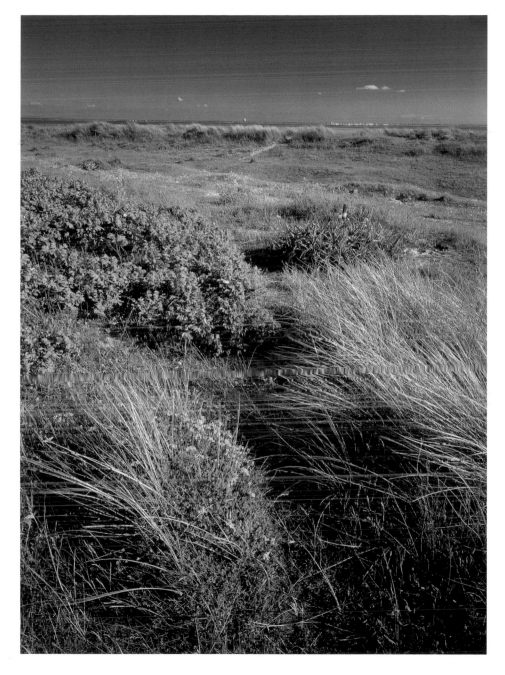

Dunes, Lytham St Anne's
Strictly speaking I was in St Anne's at
this point, rather than Lytham, but the
two are almost inseparable and the
portmanteau name is frequently used.
In the distance, beyond the wide Ribble
Estuary, Southport can just be seen.

The Plough at Eaves
The Plough at Eaves is tucked away in a quiet corner of the Fylde (look
for Cuddy Hill on the map); for years I never even knew it was there, but
pottering about on a bike is a great way to find new places.

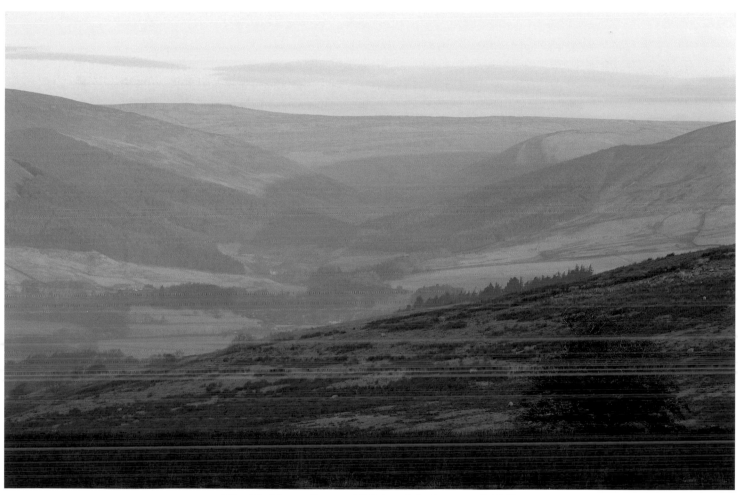

The Hodder valley and Whitendale from Hall Hill
This is not just the heart of the Forest of Bowland, but the heart of the United Kingdom: the tiny village of Dunsop Bridge, partly visible in the middle of the picture, is often stated to be the geographical centre of the UK. Purists maintain that the exact centre point is actually on the moors a little further north, but still within the area of this view.

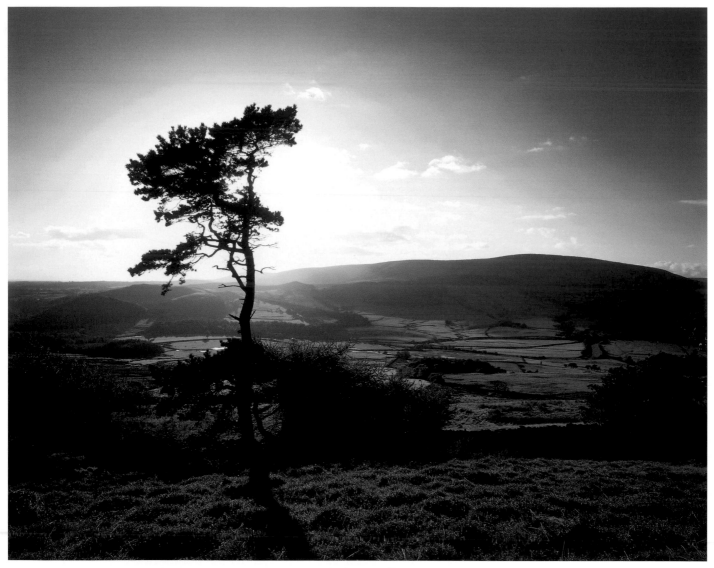

Kitcham Hill
'Freedom to Roam' came to Lancashire in September 2004, and huge areas of the Forest
of Bowland, in particular, were legally opened to walkers for the first time. To celebrate,
I made my first visit to Kitcham Hill above the Hodder valley. A lack of paths made
for some tough going but the views were terrific.

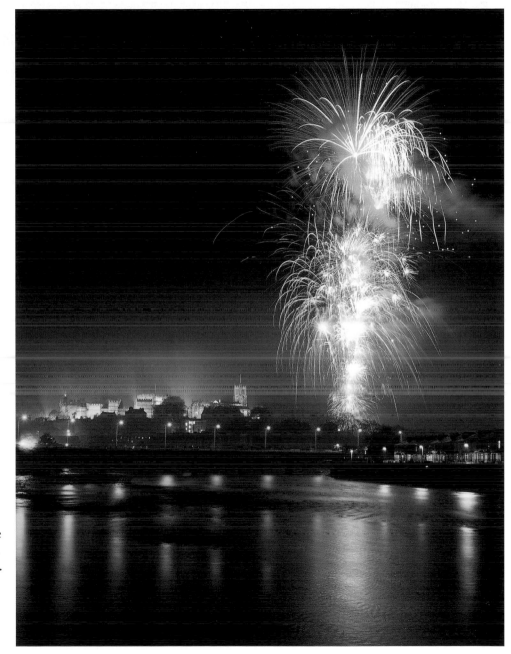

**Fireworks over the River Lune
and Castle Hill, Lancaster**
Lancaster's Castle Hill is the regular
venue for a major fireworks display
on the Saturday nearest to 5
November. The castle site, above an
ancient crossing of the River Lune,
has been a fortified position at least
since Roman times. Large parts of the
present building, including the central
keep, date back to the Norman period.

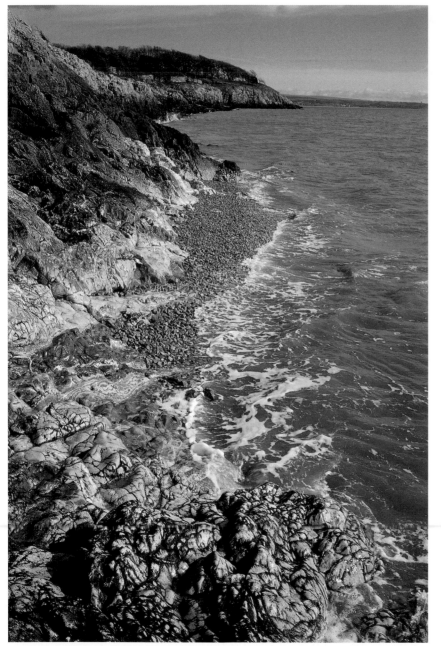

Shoreline at Silverdale
These low cliffs are just a short walk
south from Silverdale village. I'd been this
way many times, but never noticed the colourful
bands of calcite crystals and the red stain of
haematite until I passed while they were still
wet from the retreating tide.

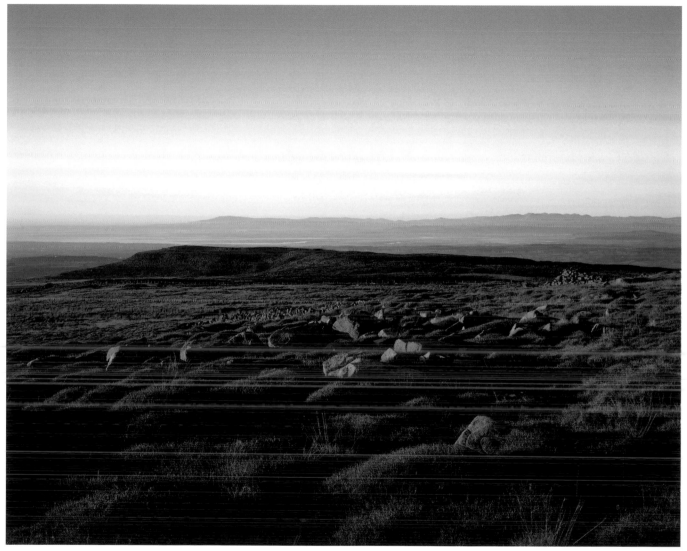

Evening on Grit Fell
Grit Fell is on the main northern ridge of the Bowland Fells and is fairly easily
reached from the road at Jubilee Tower. Many people drive up to Jubilee Tower
on fine evenings to watch the sunset, but few make the extra effort to reach the far
superior views from Grit Fell or Clougha Pike, which is in the middle distance here.
In the distance are Morecambe Bay and the Lakeland skyline.

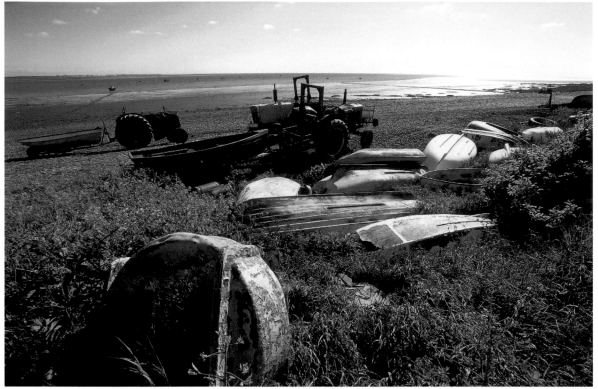

Shoreline at Lytham
I liked the colourful, ramshackle nature of this collection of dinghies and
ancient tractors. You may just be able to discern some misty blue outlines
on the horizon which are the hills of Clwyd, in Wales.

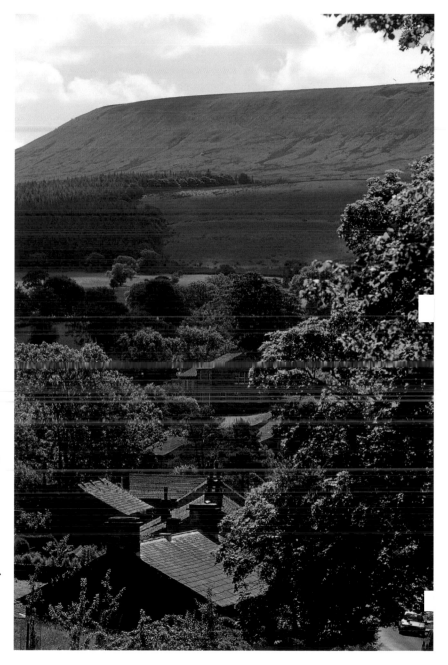

Downham and Pendle Hill

Downham is one of the showpiece villages of the Ribble valley, indeed of Lancashire as a whole. For decades Downham's claim to fame was as the location for the 1960's film *Whistle Down the Wind*, but more recently it has acquired new renown as the setting for the BBC family drama *Born and Bred*. One reason why Downham is so suitable for this kind of filming is the absence of overhead cables and TV aerials. This is enforced by the Assheton family, who still live in the village.

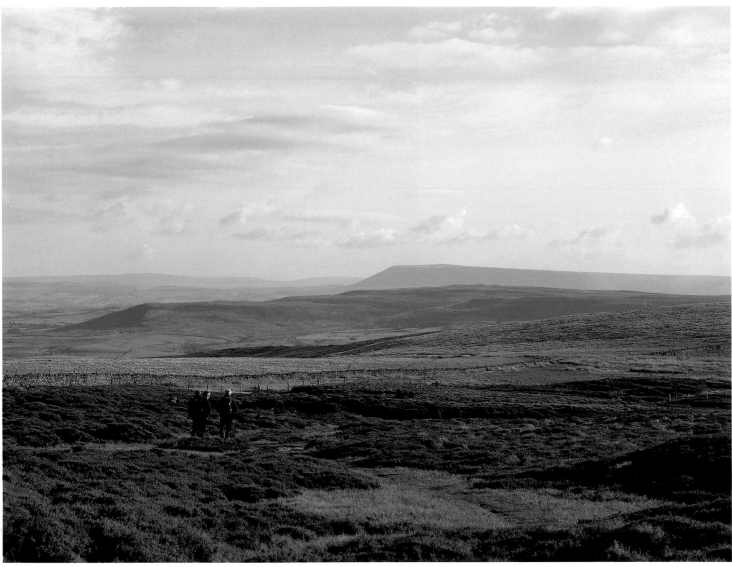

Walkers at Dunsop Head
Before the Right to Roam, the track over Dunsop Bridge was one of a small number of legal routes over the high ridges of Bowland. Pendle Hill appears to right of centre, beyond the intervening ridge of Easington Fell. On the left skyline are the Pennine moors of east Lancashire.

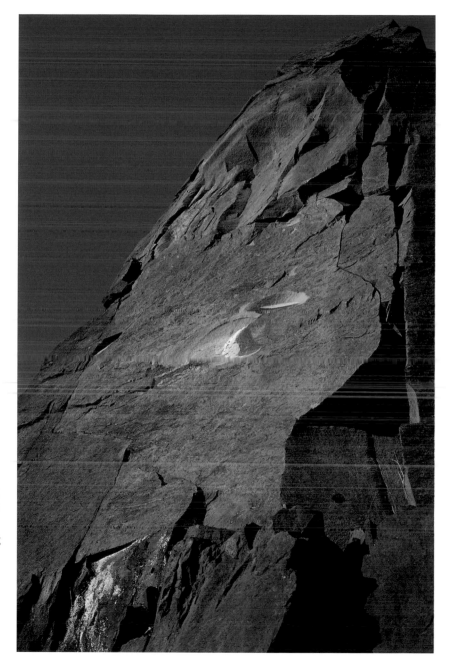

Troy Quarry, near Haslingden
One usually thinks of the Millstone Grit as being grey or even black, but unweathered rock can be remarkably colourful. This section of rock had been exposed by a recent rockfall. Warm evening light emphasised the colour but it is accurately recorded: no filters were used.

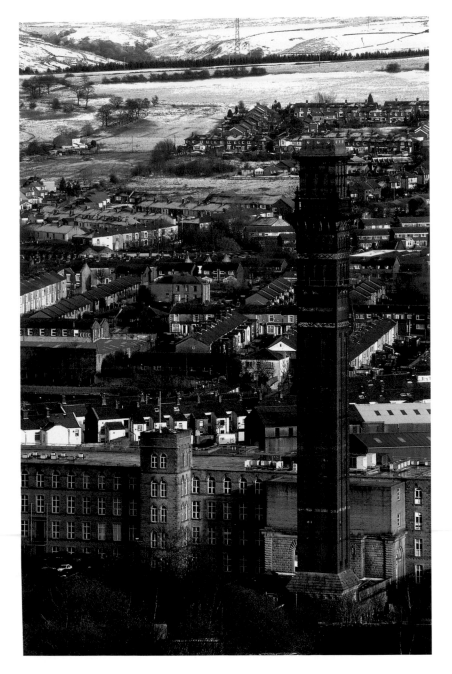

India Mill, Darwen
India Mill, and specifically its chimney, dominates the small town of Darwen. Dating from the 1860s, the chimney is 92m (just over 300 ft) high. The mill ceased production in 1991 and is now used for light industrial and office units.

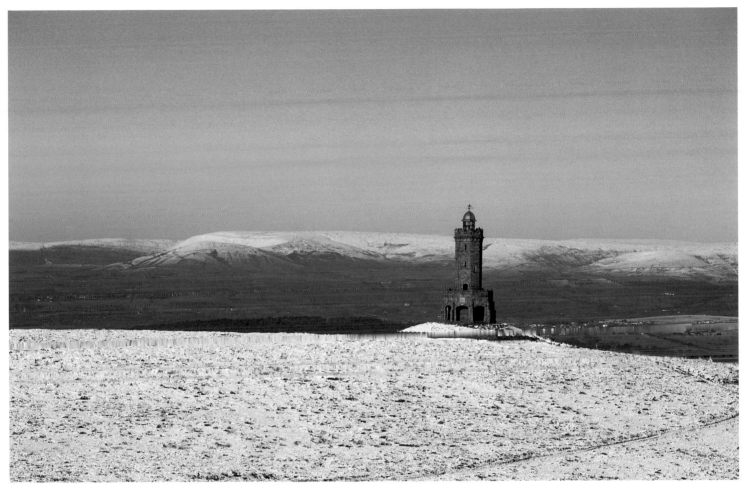

Darwen Tower and the Bowland Fells
The Right to Roam was denied on the Bowland Fells, seen in the distance, until the
twenty-first century. On Darwen Moor, by contrast, it became a reality in the nineteenth.
A long campaign came to fruition in 1896 and thousands of people climbed onto the
moor to celebrate. Construction of the tower began in 1897, marking Queen
Victoria's Diamond Jubilee as well as access to the moors.

Above Anglezarke
A string of reservoirs runs below the western edge of the West Pennine moors like a moat:
Anglezarke is the most northerly of the large ones. The reflection of the setting sun glowed
on its waters as I photographed through grasses on the edge of the moor above.

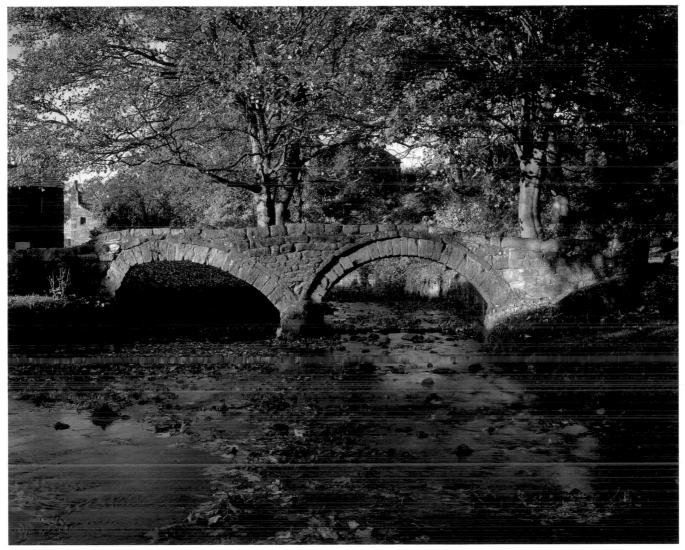

Packhorse Bridge, Wycoller
Wycoller is a small hamlet hidden in a valley in the Pennine moors, near the Yorkshire border.
It originated as a community of handloom weavers before production moved to larger mills
during the Industrial Revolution. Lancashire is mostly associated with cotton, but here the staple
was wool. The Packhorse Bridge, which is thought to be around 700 years old, has typical
low parapets so as not to impede the passage of animals carrying huge bales of wool.

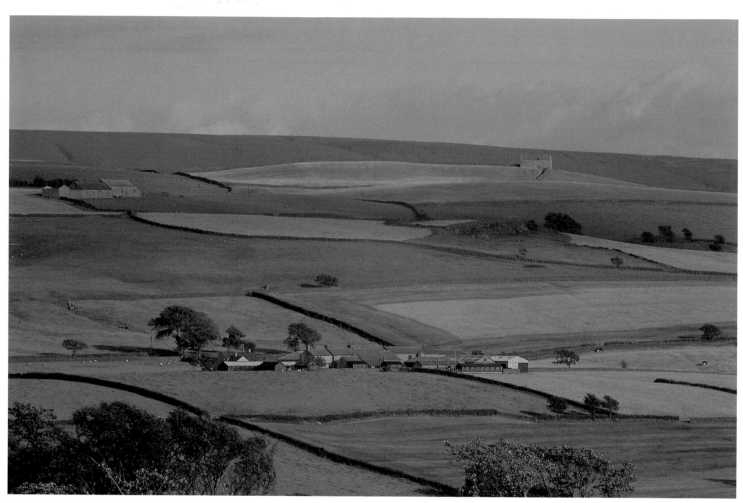

Harvest patterns, Quernmore

The Quernmore valley lies just east of Lancaster, and like many places in Lancashire, was a more industrial scene in the past than it is today. Traces of several Roman pottery kilns have been found, and quarrying was also important. The name, locally pronounced 'Kwormer', derives from 'quern', meaning a millstone.

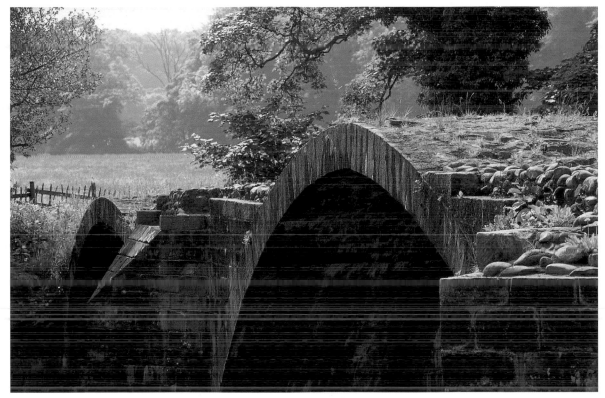

Cromwell's Bridge
Cromwell's Bridge crosses the River Hodder shortly before it joins the Ribble.
The name is misleading, as the bridge was built for the Shireburn family in
1562. According to local legend, Oliver Cromwell vandalised it, ordering the
destruction of its parapets as they slowed the passage of his troops.

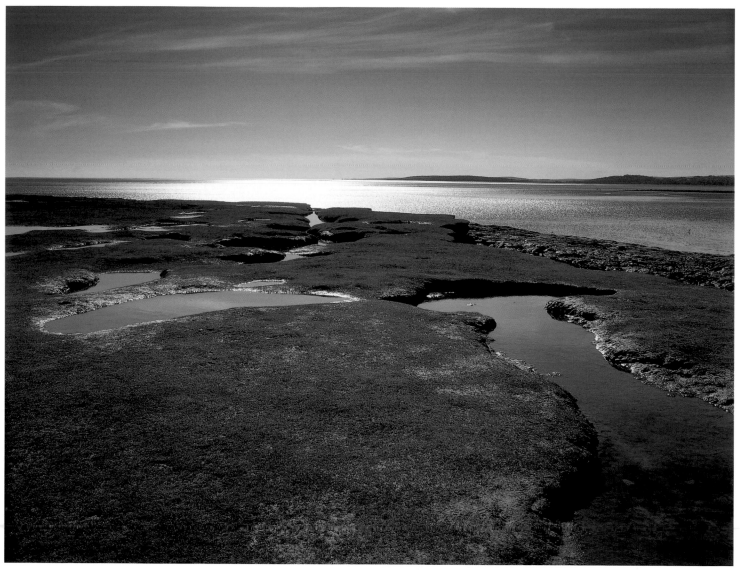

Salt-marsh at Silverdale
This is one of the transient landscapes of Morecambe Bay. You can see chunks of the marsh
eroding away on the right side of the picture. As the main channels shift over time (the cycle is
traditionally said to be roughly equivalent to a human lifetime), the salt-marsh tends to grow at
one side of the bay and shrink on the other.

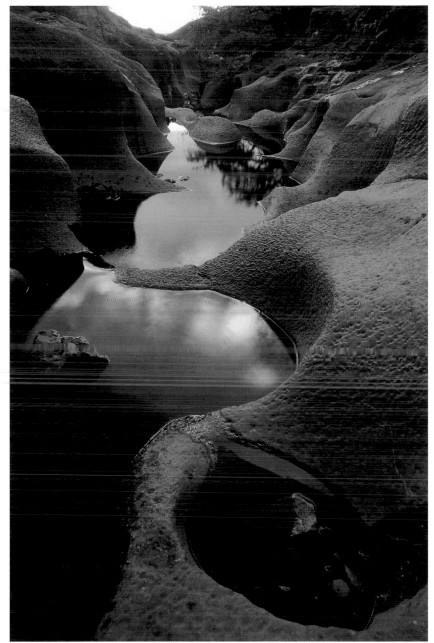

Leck Beck

This is the very edge of Lancashire – the boundary follows the beck – and the most northerly location in the book. And just to confuse everyone, it is actually in the *Yorkshire* Dales National Park. A wedge of Lancashire territory pushes between North Yorkshire and Cumbria, rising to 686m (about 2250ft) at Crag Hill - the highest ground in the county. Leck Beck lies in a fold of these hills.

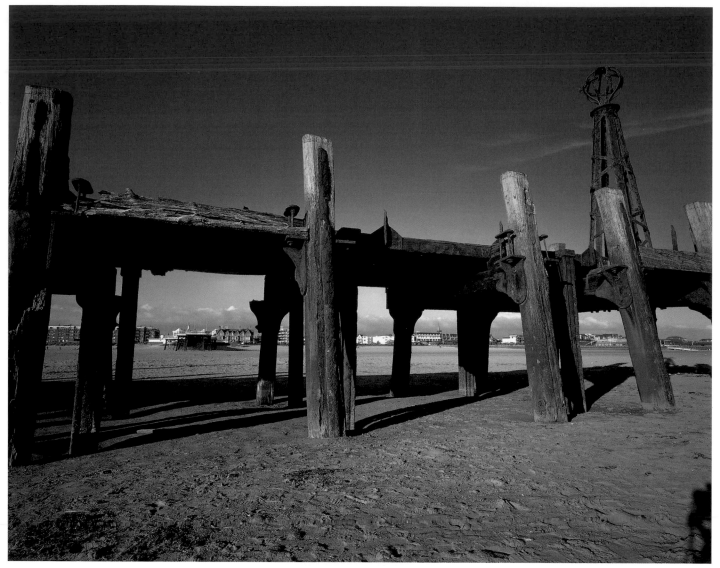

The Old Pier, St Anne's-on-Sea
St Anne's-on-Sea is usually called simply St Anne's, and is often considered part of a single town
with neighbouring Lytham. These are the remains of a jetty that once formed the seaward
extremity of the town's pier. Opened in 1885, the pier suffered severe damage from fires in 1974
and 1982 and most of it was demolished. A short section (just visible) remains in use.

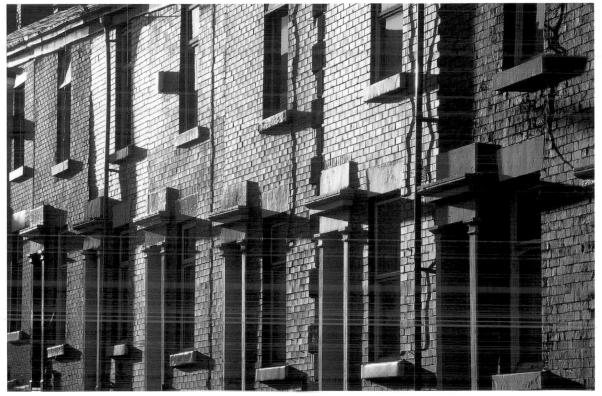

Infirmary Street, Blackburn
Terraced housing is part of the stereotype picture of Lancashire, but there
is a lot less than there was, say, fifty years ago. This may or may not be a
good thing; it certainly can yield a striking picture when the light is right.

Towards Pendle Hill from Bleara Moor
Bleara Moor is on the eastern edge of Lancashire, above Earby. My first acquaintance with it came when riding the Lancashire Cycleway; the climb onto the moor is one of the toughest on the whole route. Once I'd got my breath back I could appreciate the view across the Ribble valley towards Pendle Hill, and I came back later to get this shot.

Flowers and fields, Quernmore valley
Most of the Quernmore valley lies within the Forest of Bowland Area of Outstanding Natural
Beauty, affording it some protection against inappropriate development, and despite its closeness
to Lancaster, it remains quiet and largely pastoral. This scene is on the minor road which climbs
over towards Littledale.

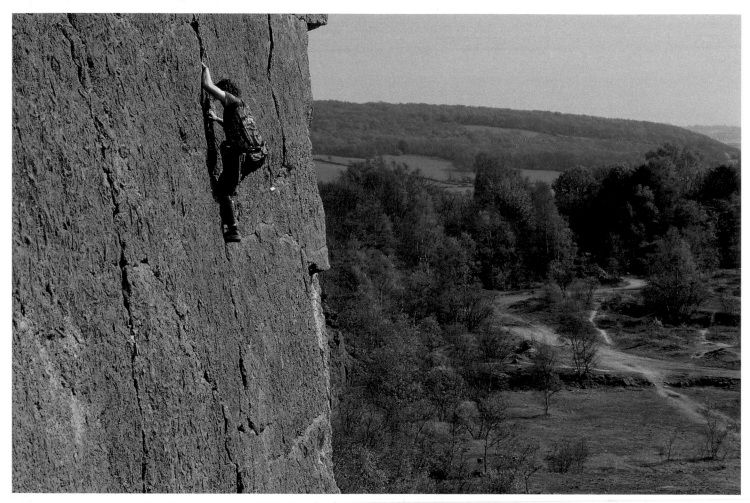

Climber at Trowbarrow
The limestone quarry at Trowbarrow was worked until 1959 and began to attract the attention
of climbers in the late 1960s. After a successful fund-raising appeal supported by climbers and
conservation interests, it was bought by Lancaster City Council and is managed by the Arnside/Silverdale
AONB Landscape Trust, doubling as a nature reserve and as an important climbing venue. The climber is
following a route called Harijan, graded VS (Very Severe), within the abilities of most regular climbers.

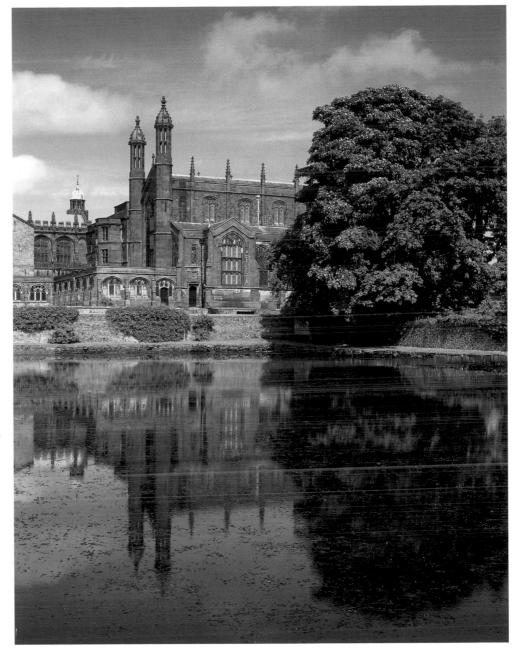

Stonyhurst
Stonyhurst College was formerly home to the Shireburn family. Later additions – mostly nineteenth-century – surround the original Elizabethan house. It was acquired in 1794 by Jesuits escaping Revolutionary France. Today it is one of the country's leading Catholic boarding schools. Parts of the buildings, and the gardens, are open to visitors during the summer holidays.

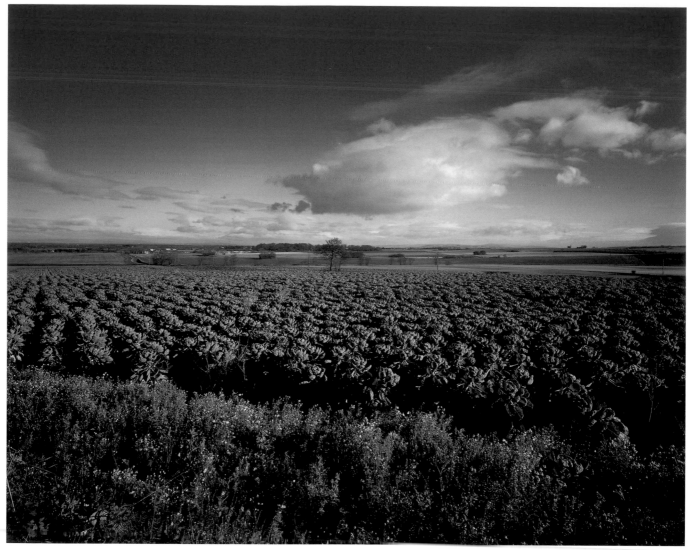

Clieves Hills, near Ormskirk

Clieves Hills rise barely 50 metres above sea level, but this modest elevation was of great significance in the past. Until the great age of agricultural improvement in the eighteenth and nineteenth centuries, the surrounding land, only a few metres above sea-level, was marshy and often virtually impassable. Habitation, farming, and lines of communication all followed the ridges wherever possible. The area remains predominantly agricultural.

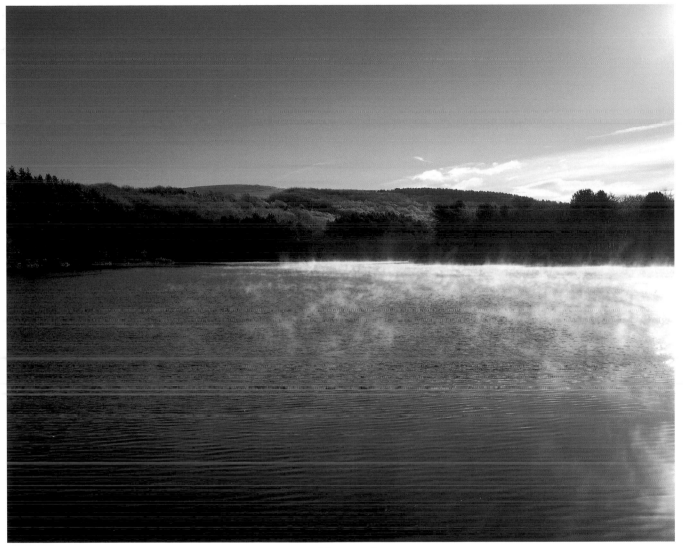

Roddlesworth
Days like this can be agony for the photographer. Perfect snow cover, sun and blue sky: it's such
a rare combination in these days of global warming that you want to be in fifteen places at once.
I had to choose, and plumped for the upper reservoir at Roddlesworth, on the northern slope
of the West Pennine moors. Part of Darwen Moor can be seen on the skyline: I went up there
later on, and got the photo of Darwen Tower which appears on page 37.

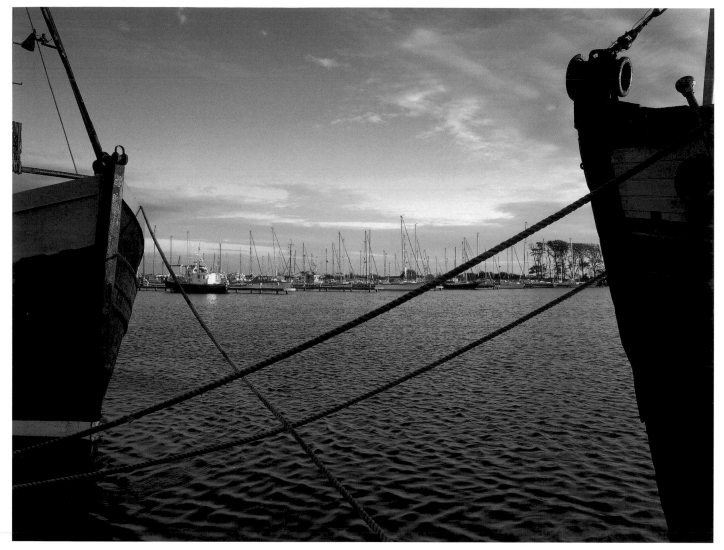

Inner harbour, Glasson Dock
For a brief period in the eighteenth century, Lancaster was the second port of the nation, but the River Lune was always shallow and prone to silting. Nearby Glasson Dock, at the mouth of the river, became the principal port, helped by its direct connection to the canal network. It is still a working port, though larger vessels now use the Port of Heysham and Glasson's inner basin is mainly used by pleasure craft.

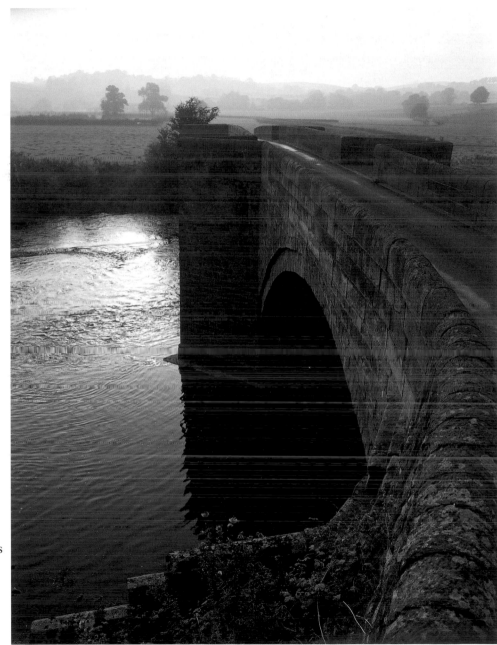

Loyn Bridge
Loyn Bridge, crossing the River Lune near Gressingham, is thought to date from the late sixteenth or early seventeenth century. I had to balance precariously on the parapet to take this shot. Just a few moments later a milk wagon came by, which was quite alarming.

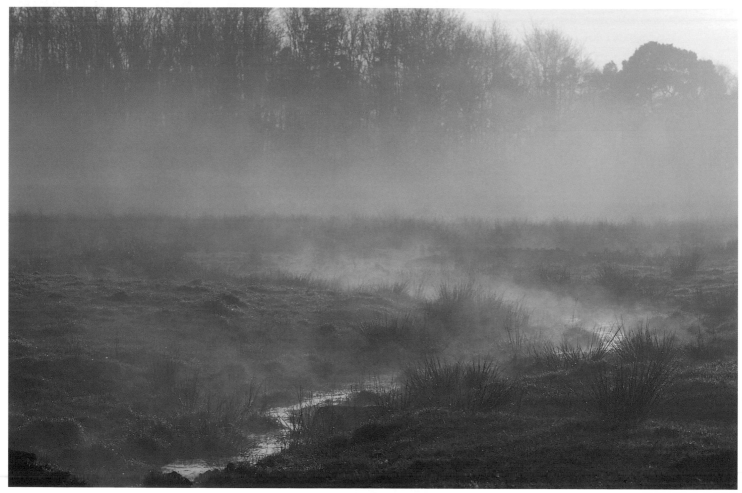

Silverdale Moss
The rising sun cast a yellow glow through the mist on Silverdale Moss,
just a stone's throw from the Cumbrian border.

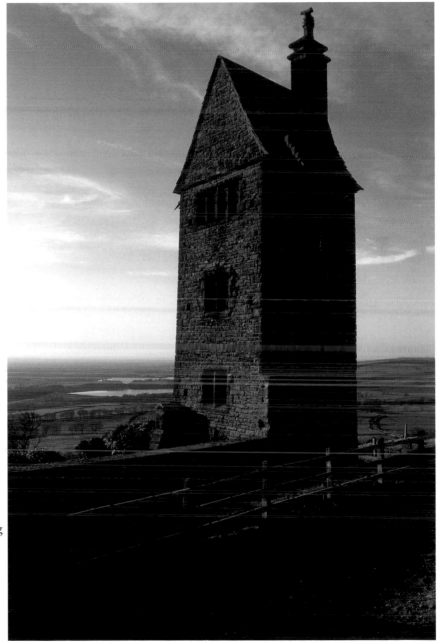

Pigeon Tower, Rivington
Lever Park, sprawling across the steep slopes of
Rivington Pike, is full of oddities. Its replica of
Liverpool Castle (seen later in the book on page
104) is one and the Pigeon Tower is another. It
was built partly for pigeons and partly as a sewing
room. Nearby are the ruins of Roynton Cottage,
said to have been burned down by suffragettes.

Calder Vale
The mill village of Calder Vale lies in a secluded valley in the fells east of
Garstang. I liked these steps, which turned out to be safer than they look.

Rock detail, Clougha Pike
Clougha Pike, in the Bowland Fells, is 413 metres,
or about 1355 feet, above sea level. Its summit
is a superb all-round viewpoint, and there is much
of interest around its flanks. I've been there more
times than I can count but only spotted this
curiously-weathered rock when the angle of
the light was precisely right.

Sand and shells, St Anne's
I could have spent hours out on the sands photographing patterns like these,
but it's always vital to stay ahead of the incoming tide.

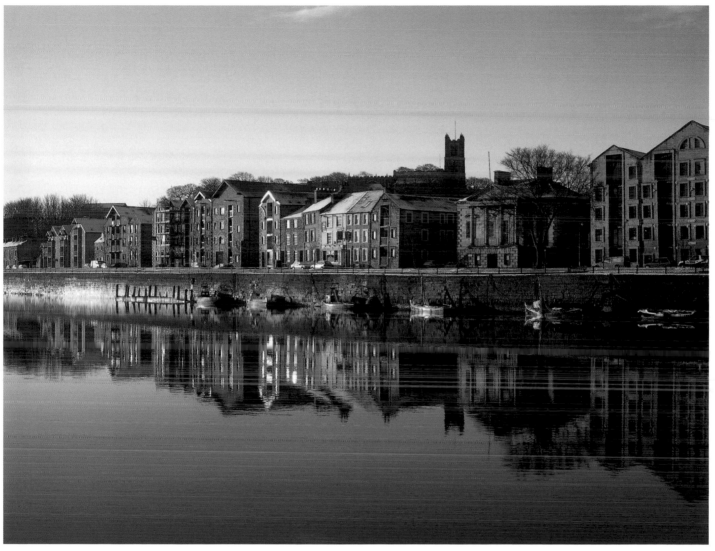

St George's Quay, Lancaster
Even allowing for home-town bias, I maintain that Lancaster has the finest urban landscapes
in the county, and this is one of its best aspects. The eighteenth century waterfront remains
largely intact, though the former warehouses have been converted to residential use. Right
of centre is the Customs House, built in 1764, and now home to the city's Maritime
Museum and behind it is the tower of the Priory Church.

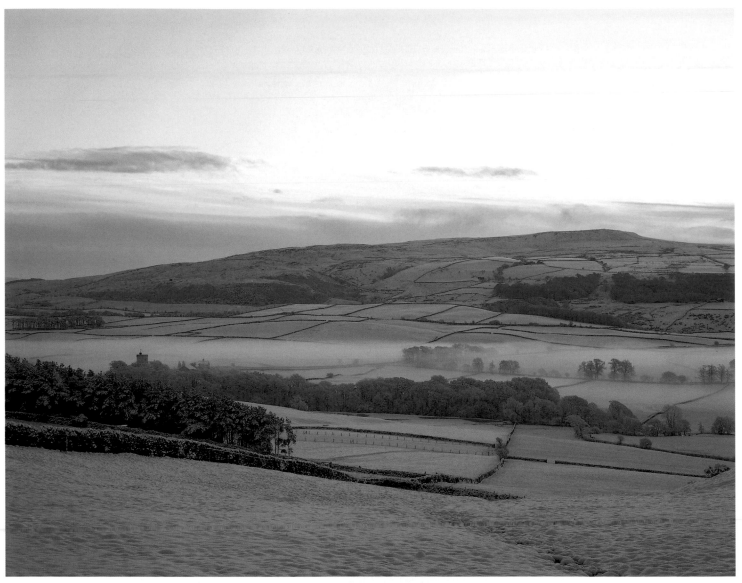

Quernmore valley and Clougha Pike
This stunning winter morning was a few years ago, but nothing much has changed in this view. Quernmore village is just out of picture to the right, but the isolated Victorian St Peter's church is visible.

Heather, Wyrcsdale
The Lancashire moors are probably at their most glorious when the heather blooms in late summer.

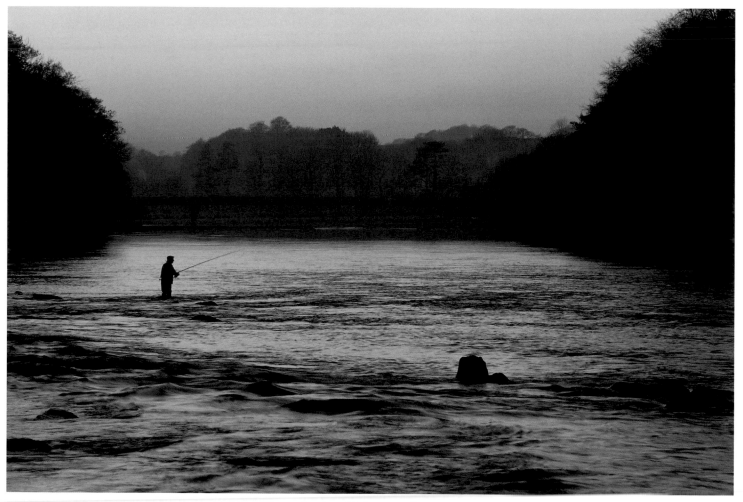

Angler, Halton-on-Lune
Halton lies just a short distance upstream from the city of Lancaster. The manor of
Halton is mentioned in the Domesday Book, and the earthworks of the Norman
motte-and-bailey fortress can still be seen in the village. The River Lune is highly
rated by anglers, notably for its salmon, but also for coarse fishing.

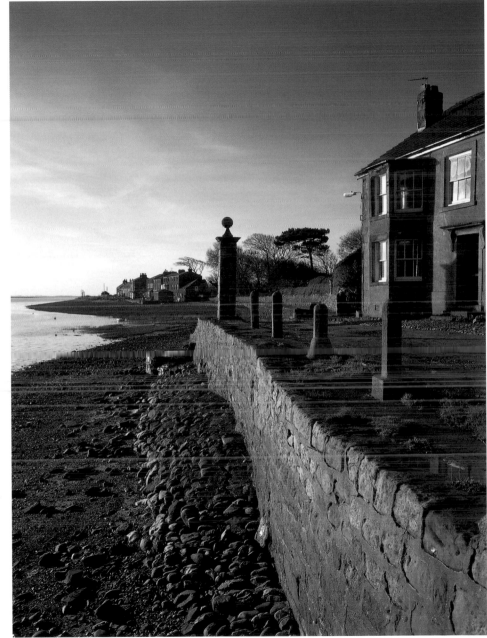

**First and Second Terraces,
Sunderland Point**
Pedants insist that the village
is called Sunderland and it's the
nearby headland that is the Point,
but locally the same name does for both.
It overlooks the mouth of the River
Lune and has a remarkably isolated
atmosphere, especially at high tide
when the access road is flooded.

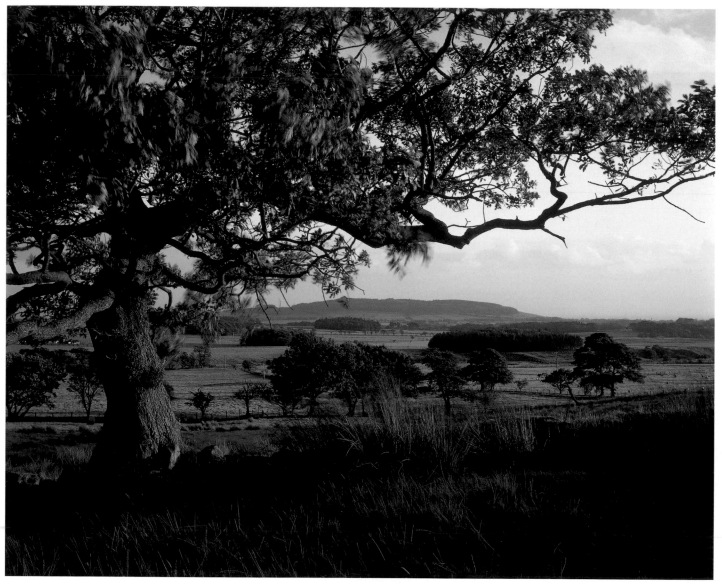

Oak tree, Bleasdale
To me this is absolutely classic Lancashire countryside, still retaining a
healthy quantity of hedgerows and trees. The low hill on the horizon is Beacon Fell,
now a country park, especially popular with Preston folk.

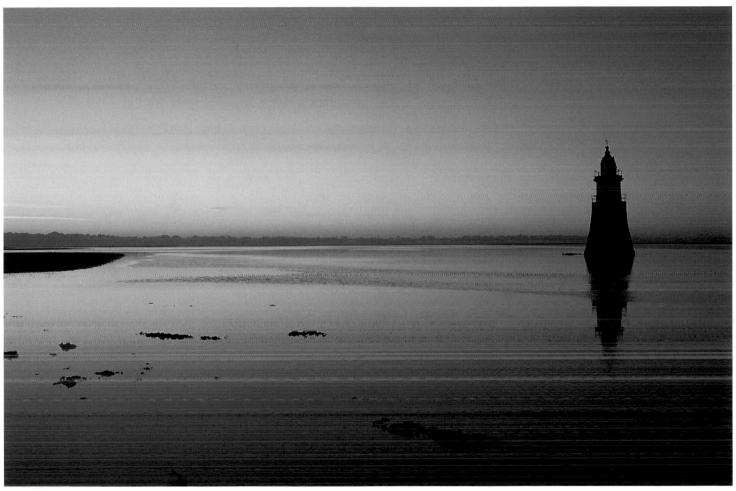

Lighthouse in the Lune Estuary
This little lighthouse still guards the mouth of the River Lune and is an important
navigational aid for vessels heading to Glasson Dock or upstream to Lancaster.

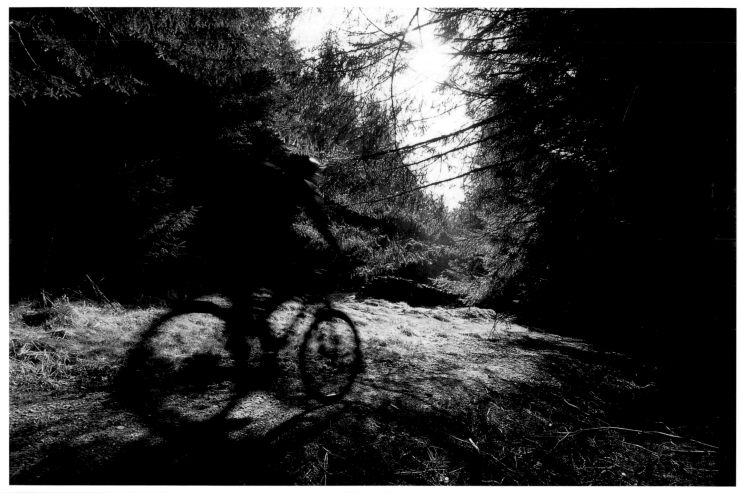

Mountain biking, Gisburn Forest
Gisburn Forest is the largest single area of forest in today's Lancashire and is
popular not only for mountain biking but for walking and bird-watching, while the
adjacent Stocks Reservoir is highly valued by anglers.

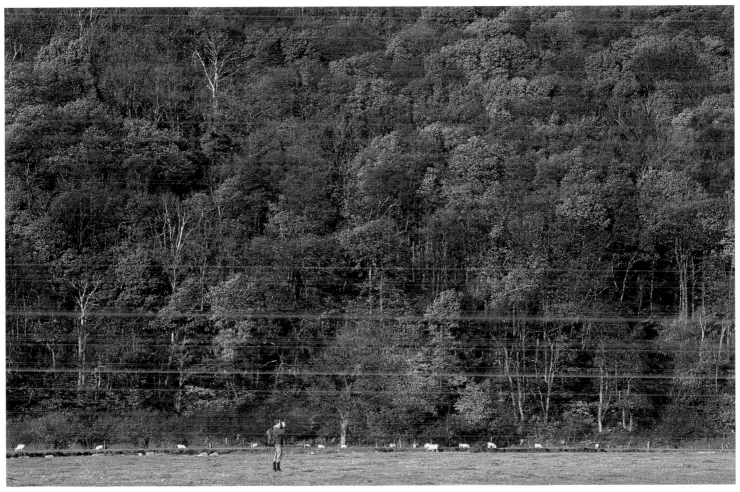

Birdwatcher, Lune valley
The level flood-plain of the Lune contrasts with the steep wooded bluff of Burton Wood.

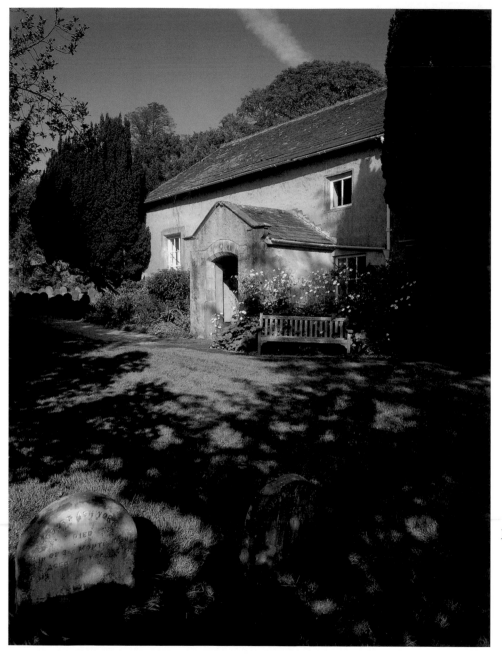

**Quaker Meeting House,
Yealand Conyers**
Lancashire is of central importance in the history of the Society of Friends (Quakers). It was on Pendle Hill that George Fox experienced the vision which led him to found the movement. This is a good example of a Quaker Meeting House, tranquil and unostentatious. In the nineteenth century many leading industrialists were Quakers.

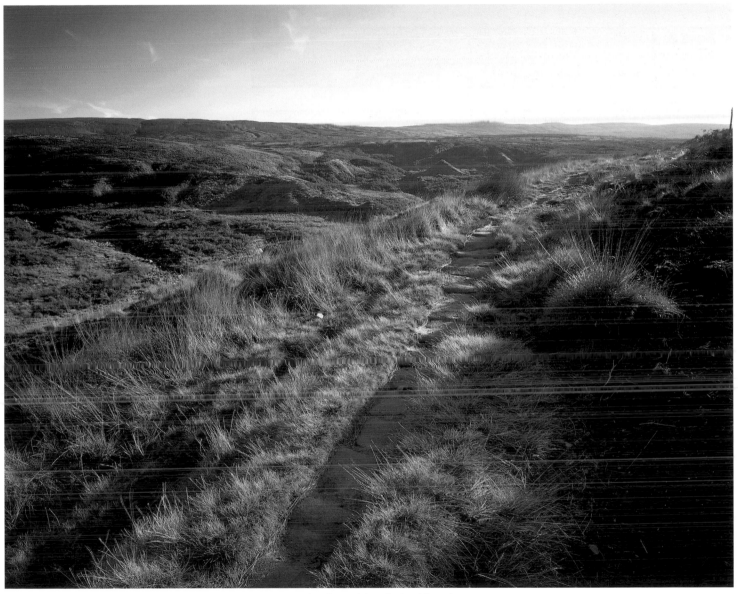

Track above Turnhole Clough
Turnhole Clough is a tributary of Wycoller Beck, and this ancient track leads out onto the
moors towards Trawden. The frost and the morning light helped to accentuate its line.

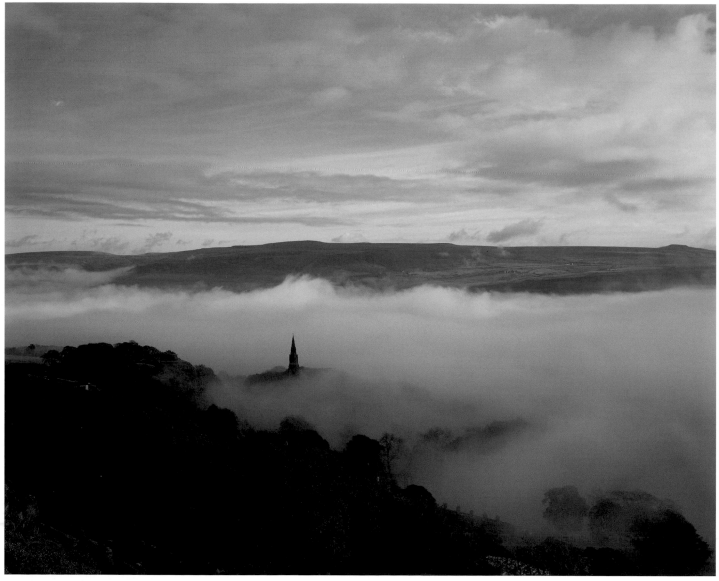

The Rossendale valley
I have to confess that I stepped outside the modern boundaries of Lancashire for this shot: the fore-
ground, including Holcombe church, is today in Greater Manchester. However, until a generation
ago, all this was Lancashire, and much of the upper valley and of the moorland beyond still is.

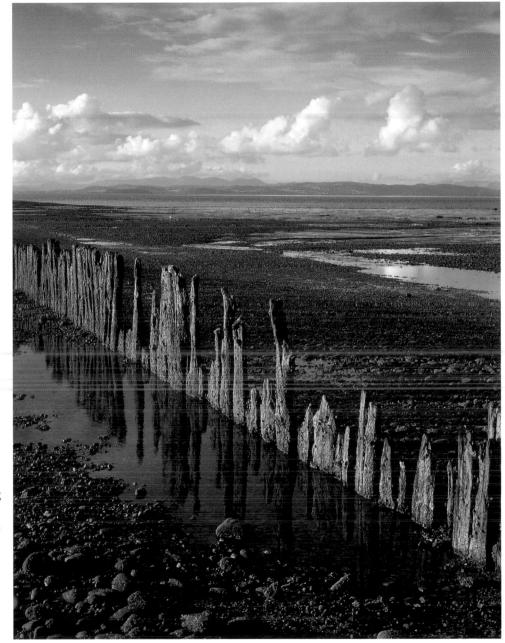

Low tide, Morecambe Bay
The viewpoint here is about a hundred metres off the promenade at Bare. The distant segment of the Lakeland skyline stretches from the Coniston Fells to Fairfield. Slightly closer is Grange-over-Sands, backed by the limestone ridge of Hampsfell. Until 1974 not only the foreground but most of the background, including the Coniston Fells, belonged to Lancashire. For many people this loss still rankles, much more than parting with Liverpool or Manchester.

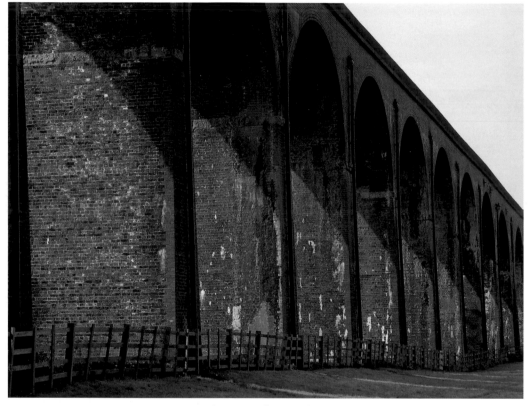

Railway viaduct, Whalley

Whalley Abbey might be the most famous feature of the village, but its most prominent structure is this 49-arched railway viaduct. It was opened in 1850 and in the early years of the line the crossing terrified passengers, to the extent that many would get off the train and walk between Whalley and Billington.

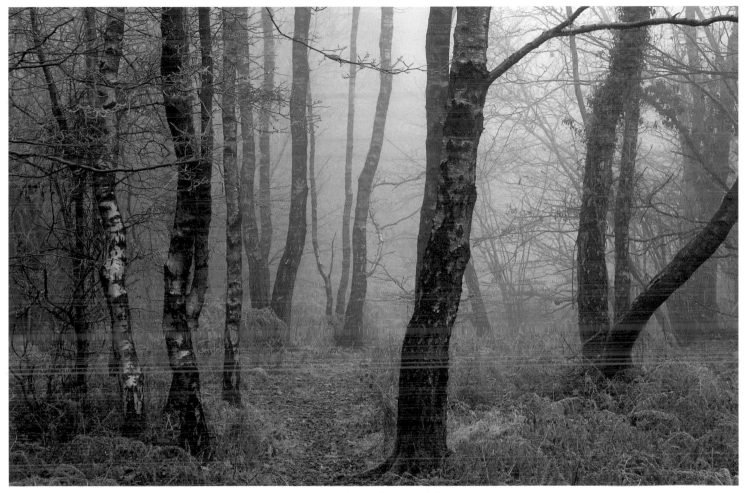

Warton Crag, frost and fog
Warton Crag rises directly above Warton village, just north of Carnforth and its
upper slopes are a local nature reserve. At 163 metres (535ft), it is an easy but rewarding
ascent, with a rich mix of crags, open spaces and woodlands, and a grand view from
the summit. Around the hilltop the remains of an Iron Age fort have been detected,
although there's little evidence visible to the untrained eye.

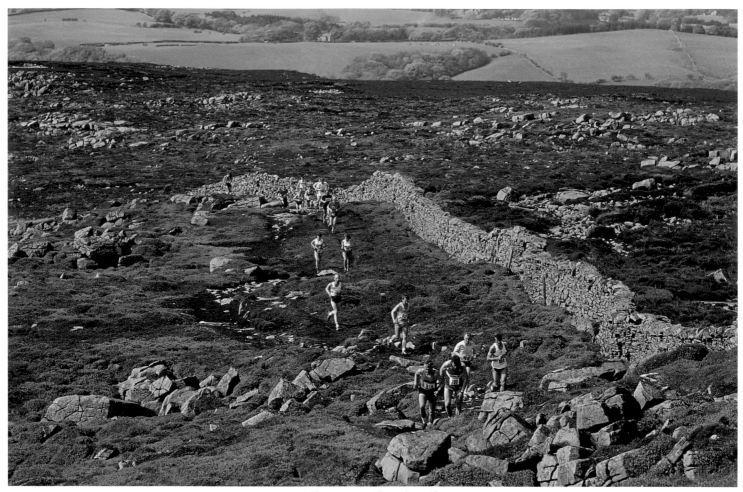

Fell-race on Clougha Pike
The annual Quernmore village Field Day, or Quernmore Sports, features sheepdog trials,
Cumberland and Westmorland wrestling, and a fell race up Clougha Pike and back.

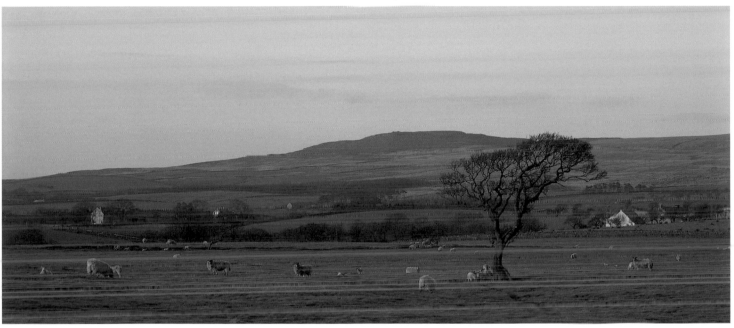

Evening, Procter Moss
Procter Moss is on a low ridge above the village of Dolphinholme, in Wyresdale.

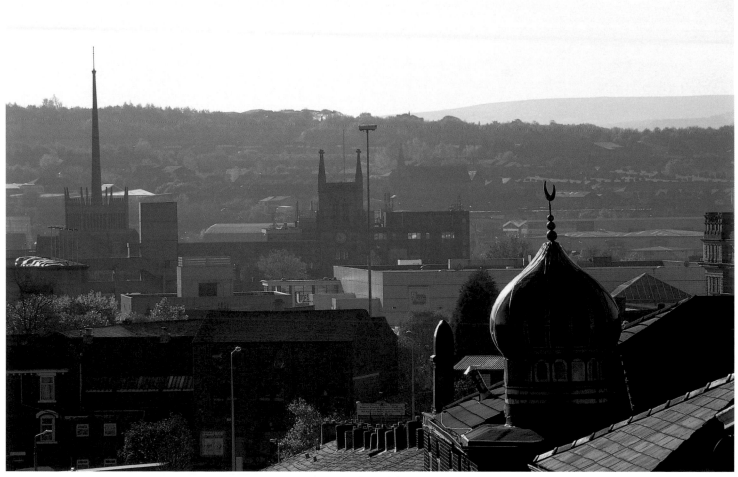

Blackburn roofscape

Though city status was conferred on Preston as part of the Queen's Jubilee celebrations in 2002, the county's cathedral is in Blackburn. Its original tower is near the centre of the shot and a newer spire on the left. A number of mosques also add interest to the Blackburn skyline.

Birk Bank, mist and frost
Birk Bank is on the flanks of Clougha Pike and is one of the areas where quarrying took place
for building stone and also the millstones that gave the Quernmore valley its name.

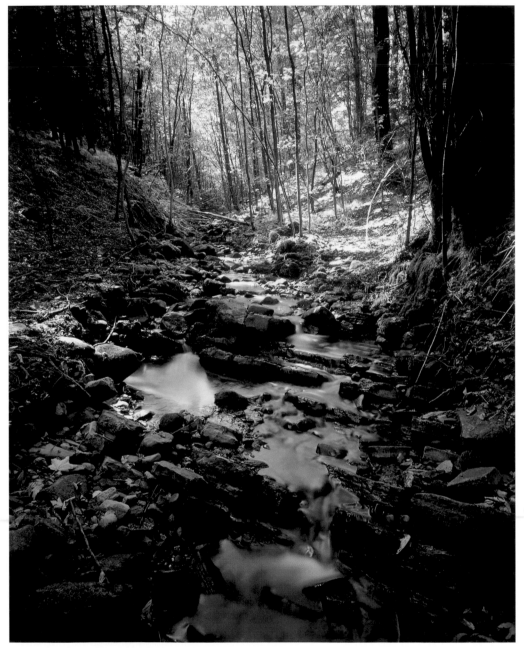

Beck below Woodfields
This little beck isn't named on the Ordnance Survey Explorer maps. It rises near Stonyhurst College and runs through this wooded valley just before joining the River Hodder. It is passed on a walk called the Tolkien Trail. J.R.R. Tolkien of *Lord of the Rings* fame certainly spent some time living at Woodfields, but claims that the area inspired the landscapes of Middle-Earth are rather fanciful. Although this does feel a bit Elvish...

Fairy Glen
Fairy Glen, near Parbold, is one of the most surprising spots in
Lancashire: at least it struck me that way on my first visit. After a
pleasant but not remarkable walk over Parbold Hill and through
the Douglas valley, we suddenly came into this shady clough, full
of little crags and waterfalls.

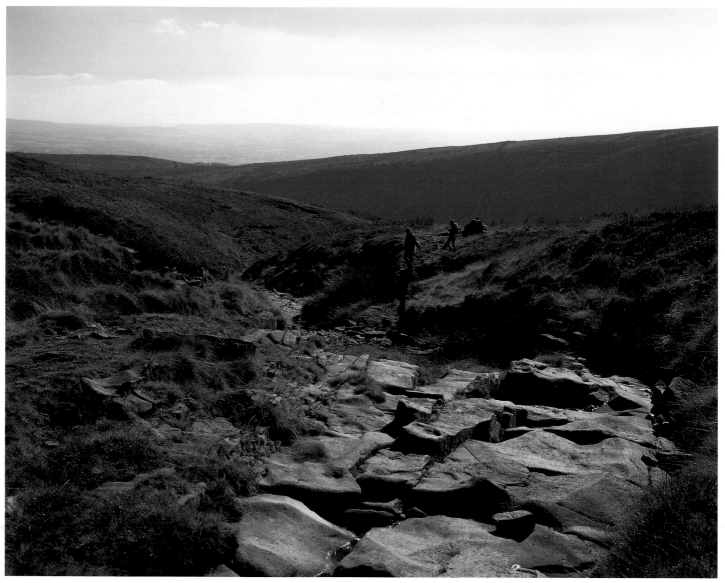

Boar Clough, Pendle Hill
When George Fox climbed Pendle in 1652, he 'went on the top of it with much ado, it was so steep,' and many modern walkers will sympathise as there are steep gradients to tackle by almost any approach. The upper plateau, however, is extensive, and gives much easier walking.

Ormskirk
Though there are some fine buildings, the main streets of Ormskirk seemed a bit bare and empty, and I found this little corner much more appealing.

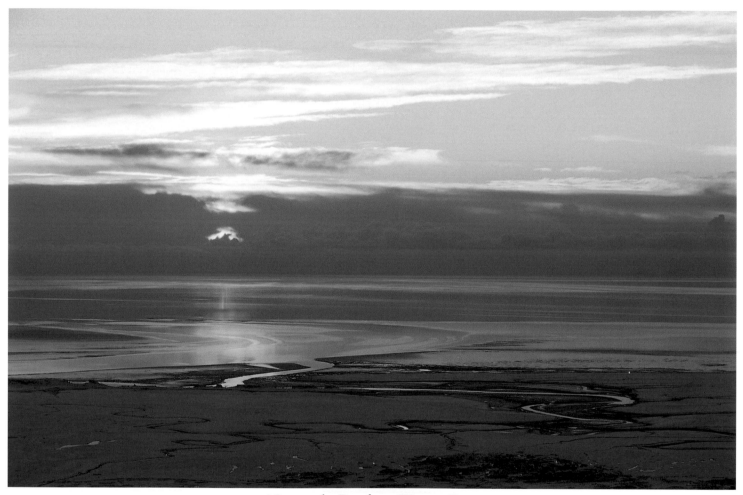

Morecambe Bay from Warton Crag
It's not often, these days, that you get decent snow cover right down to sea level.
I'd have liked a clearer horizon but this subtle sunset has its own appeal.

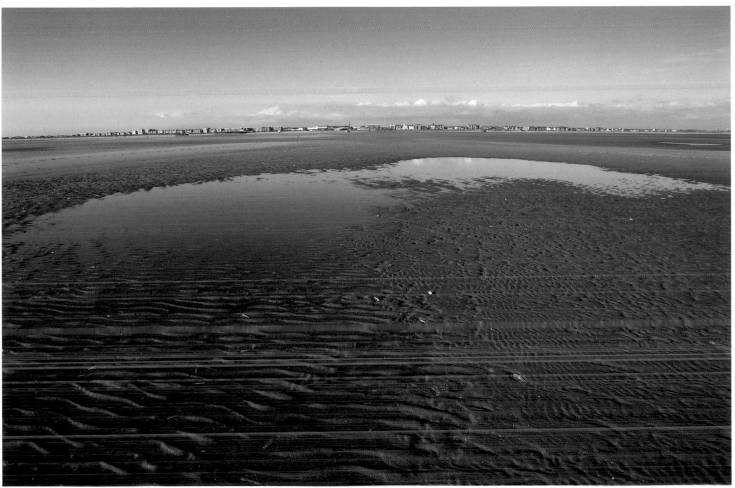

St Anne's Sands
The vast extent of the sands at St Anne's becomes apparent in this view.

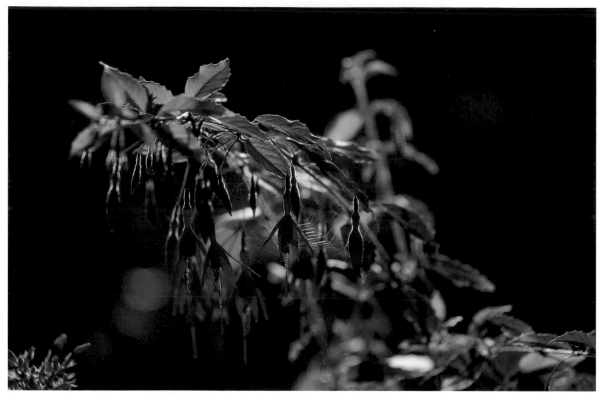

Coronation Gardens, Waddington
Waddington, near Clitheroe, is one of the most photographed villages in Lancashire and
I felt that the conventional angles had been done to death. Instead, on a still summer evening,
I was drawn to photographing details in the Coronation Gardens, like this fuchsia.

The Old Grammar School, Garstang
I confess I'd been to Garstang many times and never really noticed this unassumingly beautiful building, but I took an interest when I was looking for places to hold a photographic exhibition, as it is now a community arts centre.

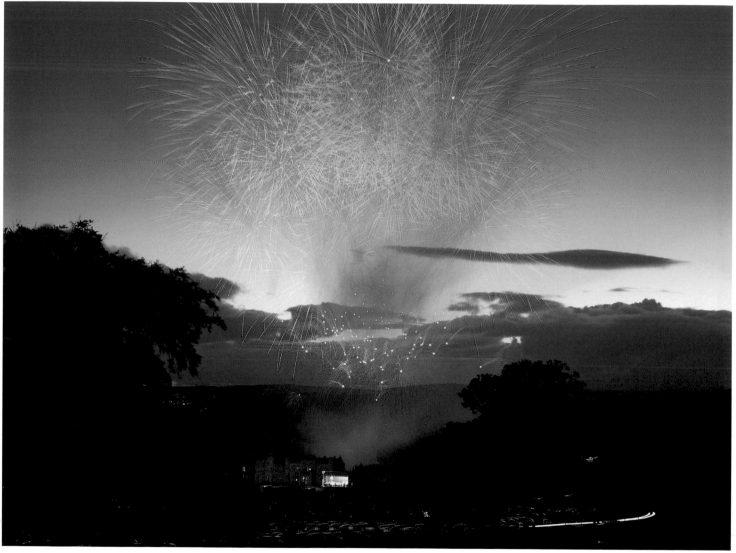

Fireworks over Leighton Hall
Leighton Hall, in the Arnside-Silverdale AONB, is home to the Gillow family, and is open to the
public on most days during the summer months. A major attraction is the collection of birds of
prey, and there are regular free-flying displays. The estate also hosts a variety of special events
such as craft fairs and open-air plays and concerts, like this one.

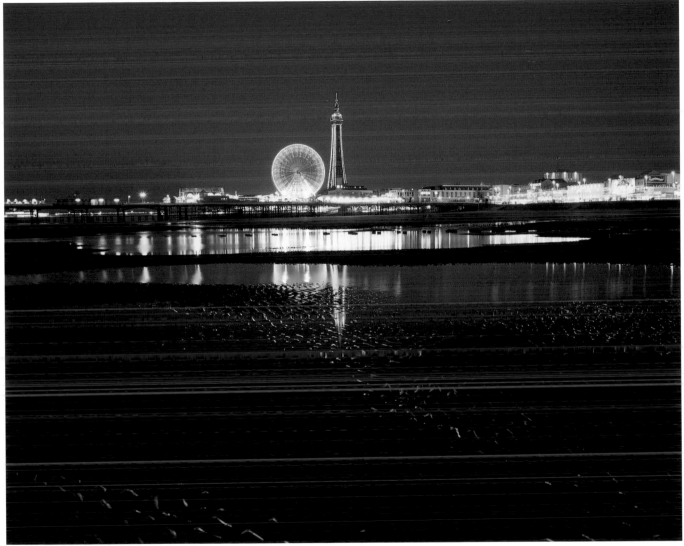

Blackpool Tower and illuminations
Blackpool has been staging its illuminations, with interruptions only for two world wars, since 1912. Today the illuminations stretch almost ten kilometres from Starr Gate to Bispham, and the best way to see the full length is from the top of one of Blackpool's famous trams. Blackpool Tower is 158 metres (518ft) tall and was opened in 1894. It's often said to have been intended as a rival to the Eiffel Tower, though it is only about half the size. Still, it is a landmark which can be seen from many places in Lancashire.

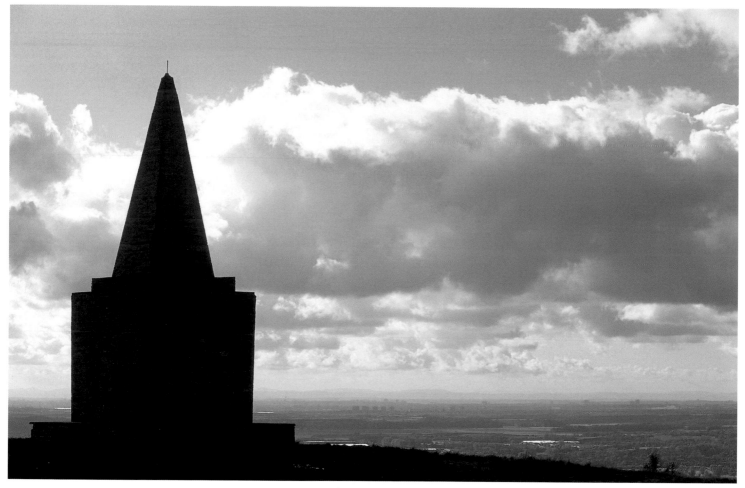

Ashurst's Beacon
Ashurst's Beacon stands on a hill just north of Skelmersdale. It was built during the Napoleonic wars, when fears of a French invasion were widespread. Before the invention of the telegraph, beacons were the fastest way to spread news. The view to the south-west ranges over Liverpool, with its two cathedrals, and beyond that to the Wirral and then the Clwydian Hills in Wales.

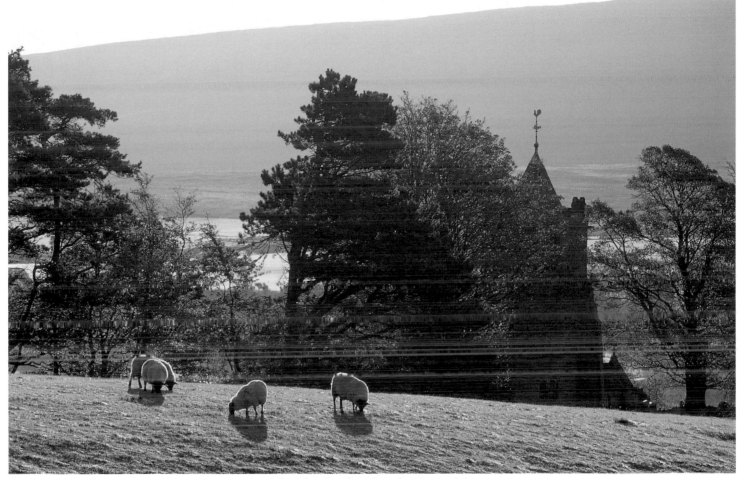

The Shepherd's Church, Wyresdale
The official name of this church, just outside the village of Abbeystead, is Christ Church.
It is commonly called the Shepherd's Church because its stained glass windows
depict Biblical scenes relating to sheep and shepherds.

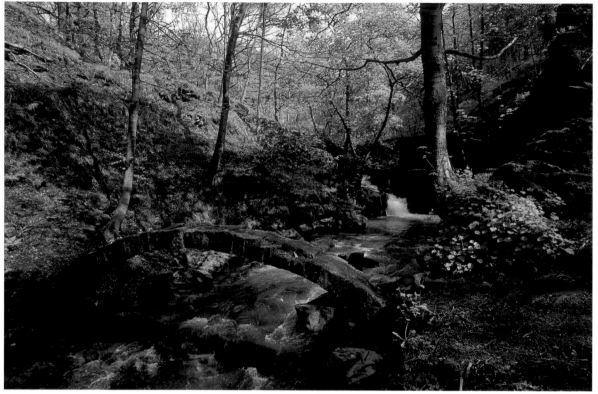

Healey Dell
Healey Dell lies just above Rochdale and in fact the county boundary
follows the stream, so half this picture is in Lancashire and the other half
in Greater Manchester. It's one of many places in the county where a
former industrial site has become a haven for wildlife.

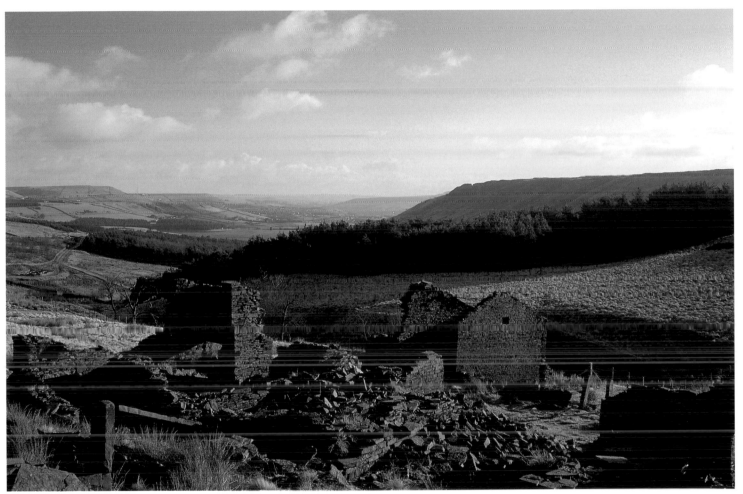

Haslingden Grane
Haslingden Grane is a striking example of rural depopulation. Once the valley was home to over 1000 people, mostly quarry-workers, farmers, and handloom-weavers. The Industrial Revolution deprived the community of income from the handlooms. Subsequently the construction of the reservoirs in the mid-nineteenth century flooded the better land. Even so, many families struggled on until the 1880s, when collapsing agricultural prices proved to be the final straw.

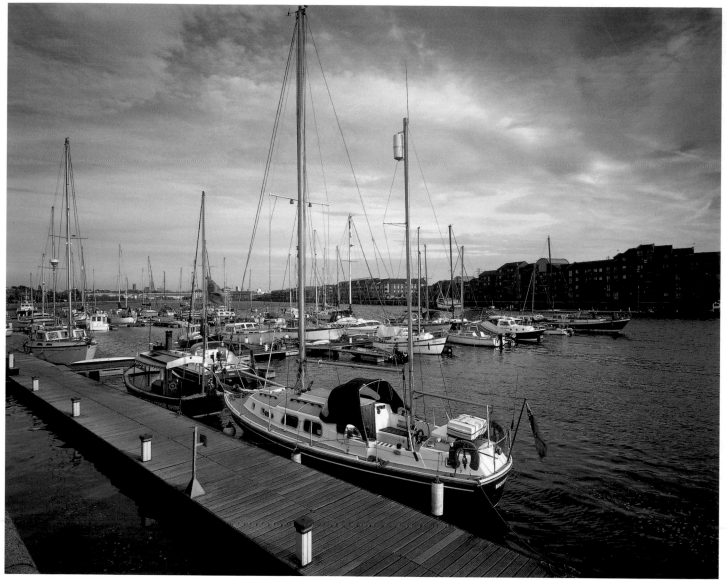

Riversway Marina, Preston
Preston became a recognised seaport in 1843 and the docks officially closed in 1981. Since then the area has been radically regenerated, with residential areas, retail outlets, cinemas, and other leisure facilities. Everything centres on the 16 hectares (40 acres) of open, non-tidal water in the marina.

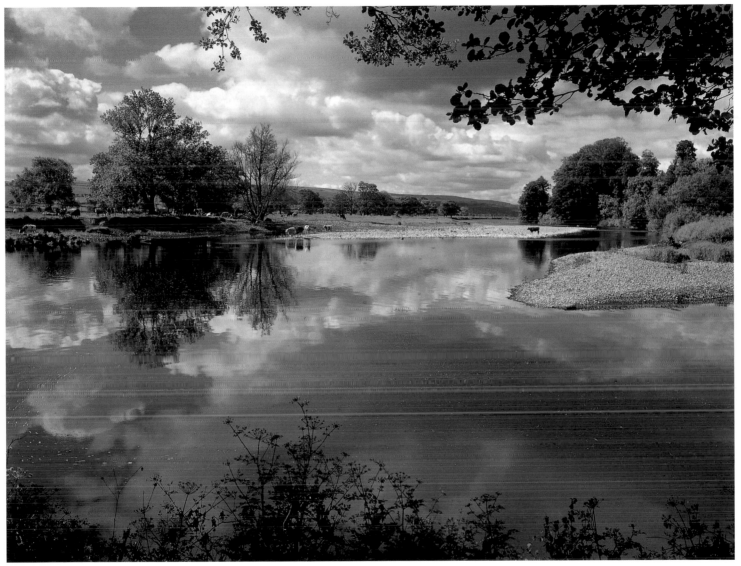

The Lune valley near Arkholme
This pastoral scene is just a short stroll from the village of Arkholme. It needed an
exceptionally calm day to yield those reflections, and in fact it was uncomfortably hot:
no wonder some of the cows were cooling their feet in the river.

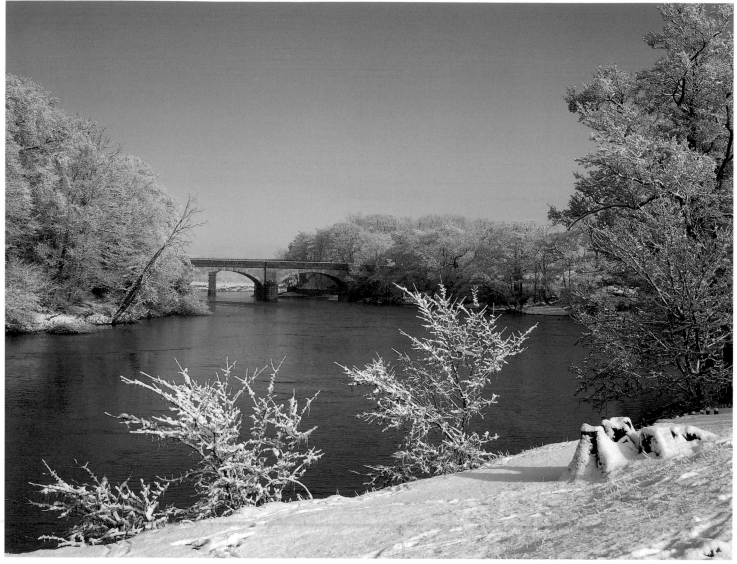

Crook O'Lune
Crook O'Lune is about 5km (3 miles) east of Lancaster, where the river
makes a sharp bend through a natural rocky barrier. It is a popular spot,
with excellent access including a cycleway from Lancaster.

**The River Ribble
at Great Mitton**
Conventional wisdom suggests that
landscape photographs are best
taken early or late in the day, but
like most rules there are many
exceptions, and this view seems
best to me when the sun is high
and sparkling on the water.

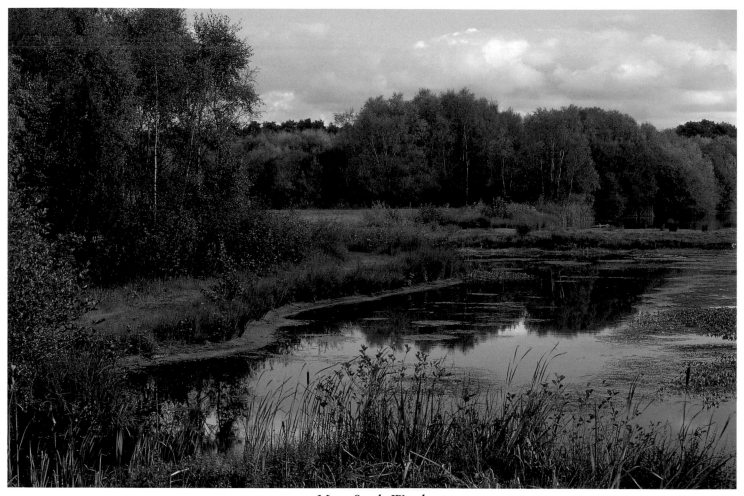

More Sands Wood
Like the more famous Martin Mere a few kilometres away, Mere Sands Wood
is a remnant of the marshy landscape which once occupied most of
lowland Lancashire. Today it is a pleasant nature reserve.

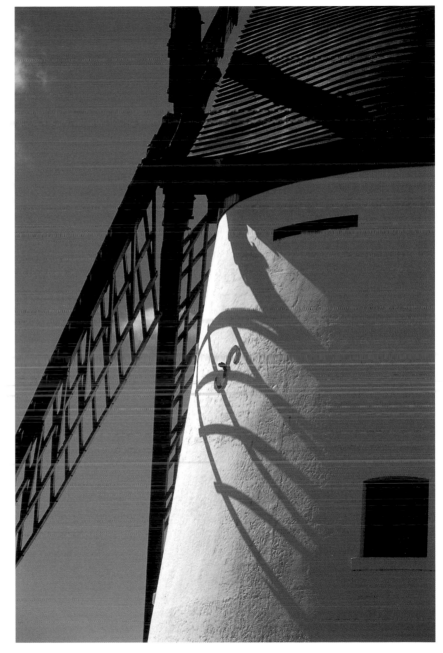

The Windmill, Lytham
Windmills were once common in lowland
Lancashire, where water power was unavailable.
This is the best-known survivor, and Lytham's
principal landmark. It is prominently placed
on Lytham Green, right by the shore. It was
built in 1805 and worked as a flour mill until
1919. Now restored, it houses a small museum.

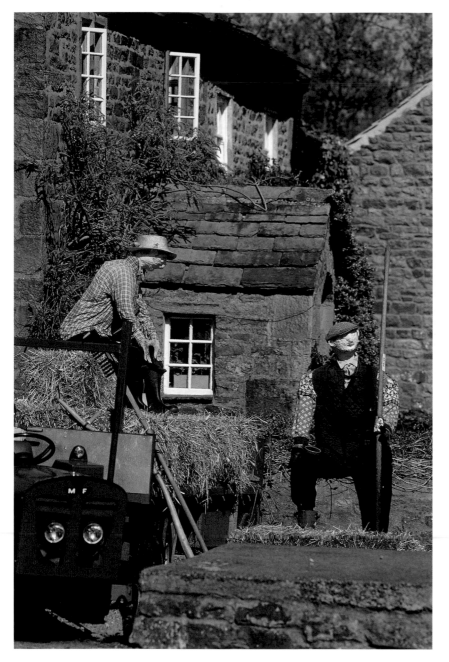

Scarecrow Festival, Wray
The small village of Wray, in the Lune Valley, has become well-known in the last ten years or so for its annual Scarecrow Festival. Originally intended as a way of promoting the village fair, which is held on the May Bank Holiday, the festival has taken on a life of its own, and attracts visitors from far afield.

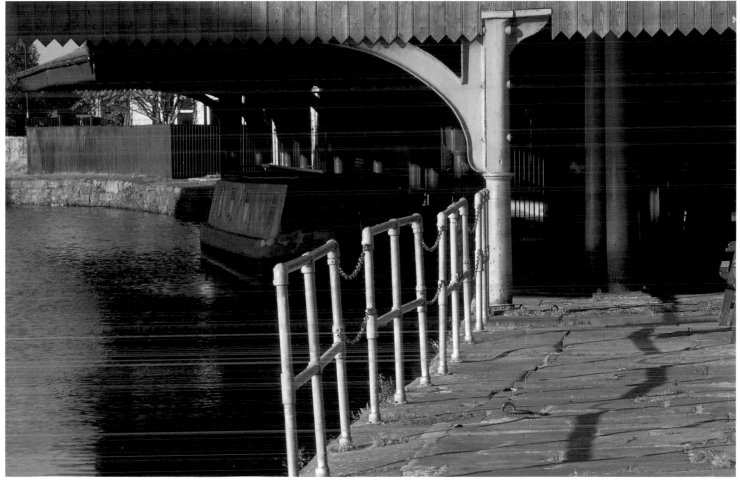

Eanam Wharf, Blackburn
Eanam Wharf stands on the Leeds and Liverpool Canal, which is Britain's longest. It's some way
above the town centre as the canal gains height for the crossing of the Pennines. The former
warehouse buildings have been smartly restored as a business development centre.

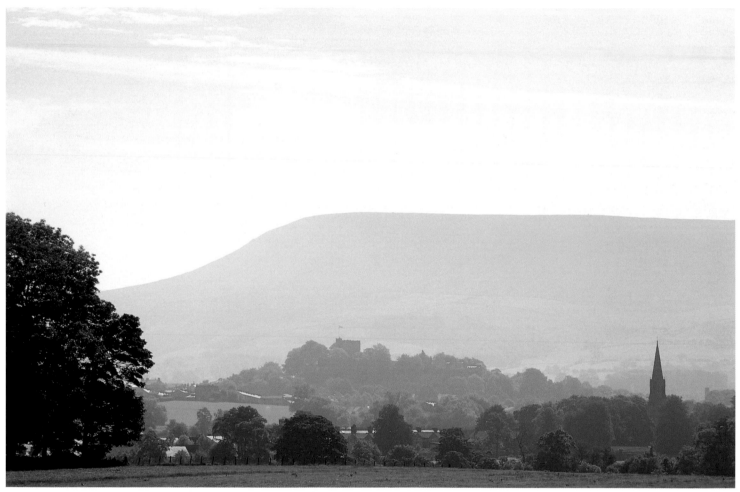

Clitheroe and Pendle Hill

It grieves me not to include a closer view of Clitheroe, which is a strong candidate for the title of 'nicest small town in Lancashire'. (It would walk away with the honours if only Castle Street were free of cars). But at least this shot gives a sense of its fine location amid the green fields of the Ribble valley and overlooked by Pendle Hill.

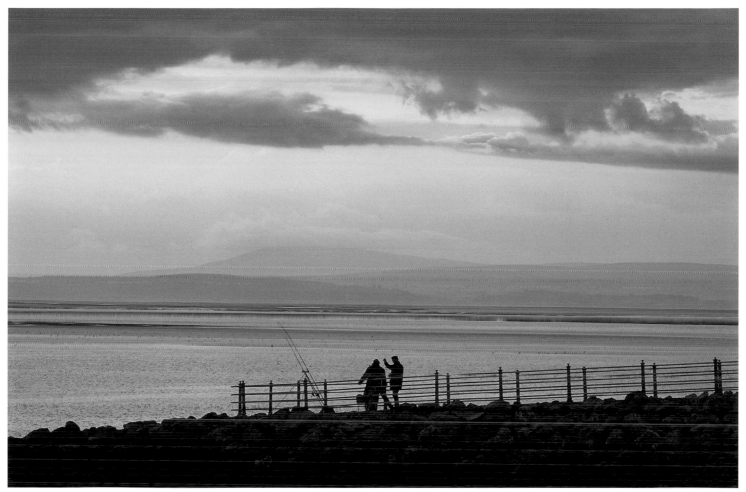

Anglers, Stone Jetty, Morecambe
In earlier times, Morecambe Bay shrimps and other produce were loaded onto trains on the
Stone Jetty for express despatch to London and other cities. Today it has been given a new
lease of life as centrepiece of the award-winning TERN Project – an extravaganza of public art,
games and puzzles on the theme of the bay's bird life. The seaward extension of the jetty,
where this picture was taken, also serves as part of Morecambe's coastal defences.

In the valley of the Marshaw Wyre
In its upper reaches the Wyre has two branches, the Tarnbrook Wyre and the Marshaw Wyre.
The road through the Trough of Bowland follows the Marshaw branch and this area can be busy
on weekends, but on a frosty midweek morning it was deserted and silent.

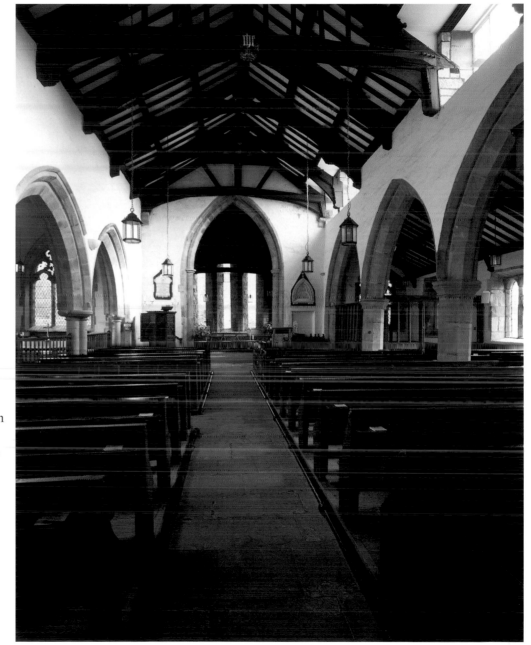

St Wilfrid's church, Ribchester
This is a fine parish church, but an additional attraction for me was that large amounts of plain glass, and particularly the generous clerestory windows, admitting plenty of light, made it easy to photograph. It stands close to the remains of the Roman fort of *Bremetennacvm*, the prime Roman site in Lancashire.

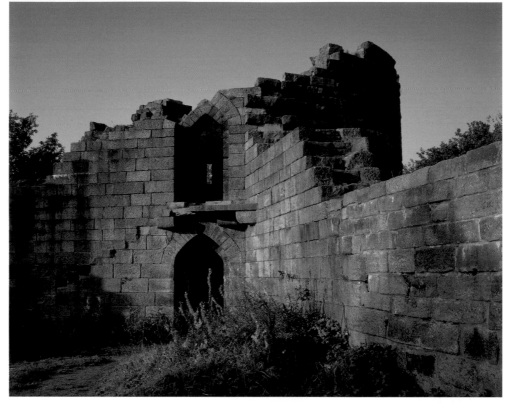

Liverpool Castle
Liverpool, of course, is not in Lancashire, but Liverpool Castle is. If that
seems paradoxical, the explanation is that this is a replica, which stands in
Lever Park, Rivington. It's shown on OS maps as a 'ruin' but in fact was built
this way, replicating the now-vanished Liverpool Castle, in the state in which
it appeared around 1900 when Lever Park was established. William Hesketh
Lever, later Lord Leverhulme, was a native of nearby Bolton. Having made
a fortune from soap, he became a noted philanthropist.

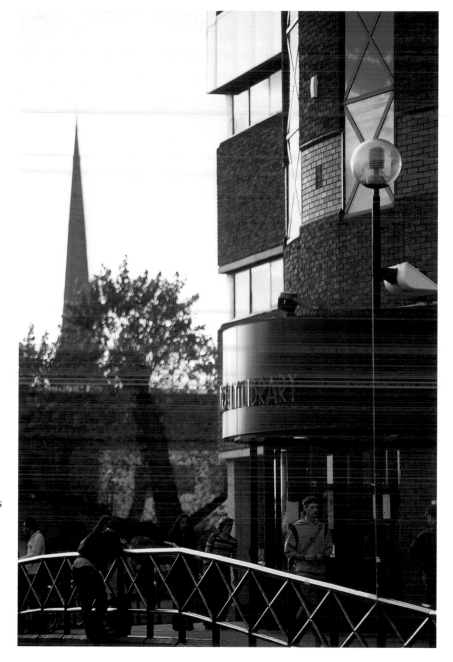

Library, UCLan, Preston
The University of Central Lancashire, to give it its full name, is one of Britain's largest. Behind is the slender spire of St Walburge's church, which still dominates the skyline of the city a century and a half after completion. At 94m (310 ft), the spire is one of the tallest in Britain.

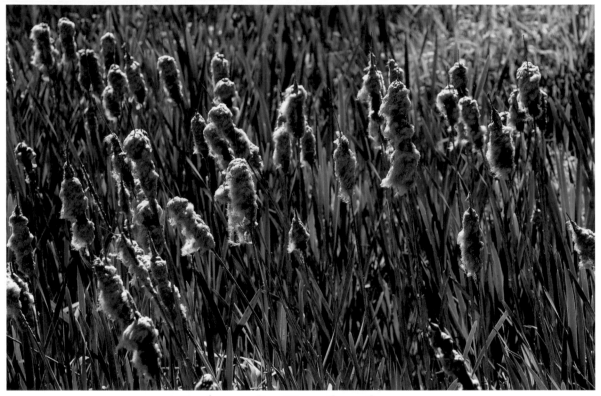

Reed-mace, Carr House Green Common
Carr House Green Common lies just outside Inskip, in the Fylde.
Reed-mace is commonly referred to as 'bulrush' although the true
bulrush is quite a different plant. The error is usually blamed on
the eminent Victorian painter Sir Lawrence Alma-Tadema, but is
now so widespread it is probably unshakeable.

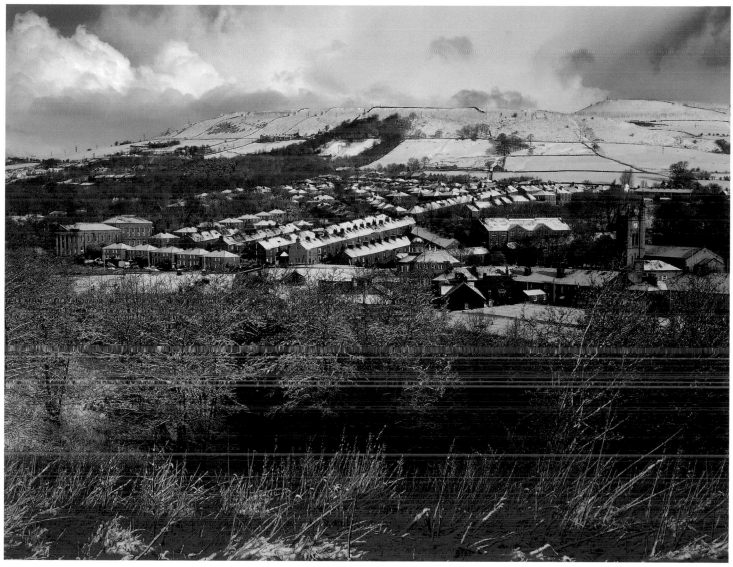

Rawtenstall, snow
Rawtenstall lies at the heart of the Rossendale valley. Its most singular claim to fame
is that it's home to Britain's last surviving Temperance Bar, also described as 'The Pub
with No Beer', in Fitzpatrick's Herbal Health Shop. Maybe this would have been
a good day for a warming Blood Tonic or Black Beer.

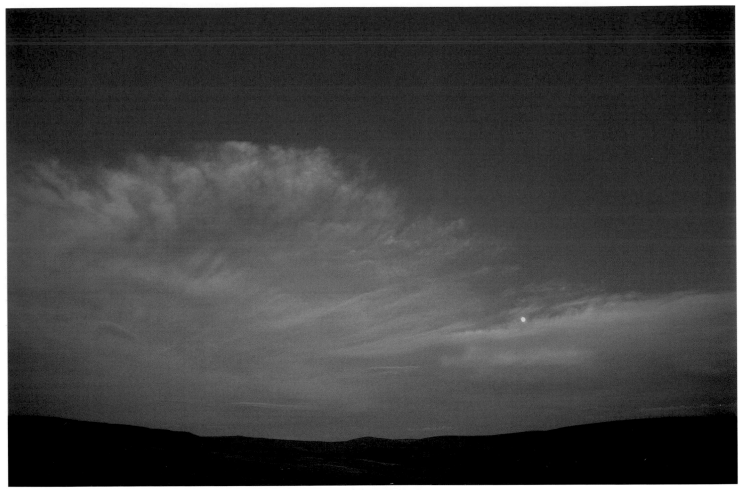

Moon over Wyresdale
You can anticipate most things, like when and where the moon will rise, but luck always pays
a part, as it did in providing this wonderful fan of clouds, painted pink by the setting sun.

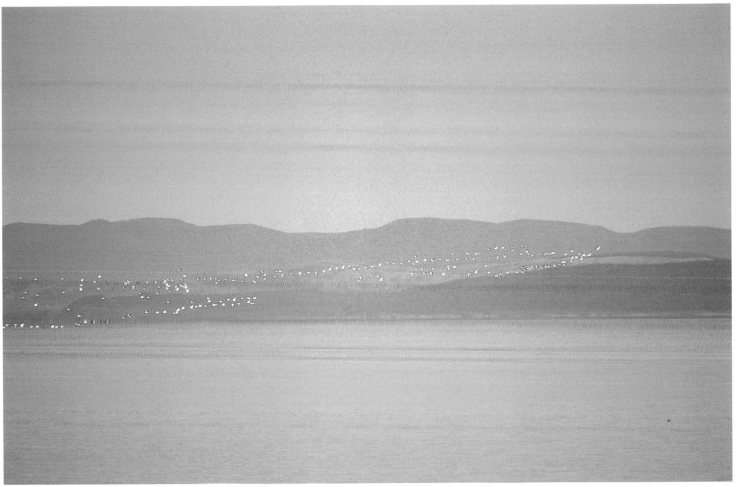

Flight of waders, Morecambe Bay
Morecambe Bay is of international importance in ornithological terms, especially for overwintering waders. A recent proposal to create a barrage across the bay raised great concern that it might trigger irreversible changes to its unique and precious environment.

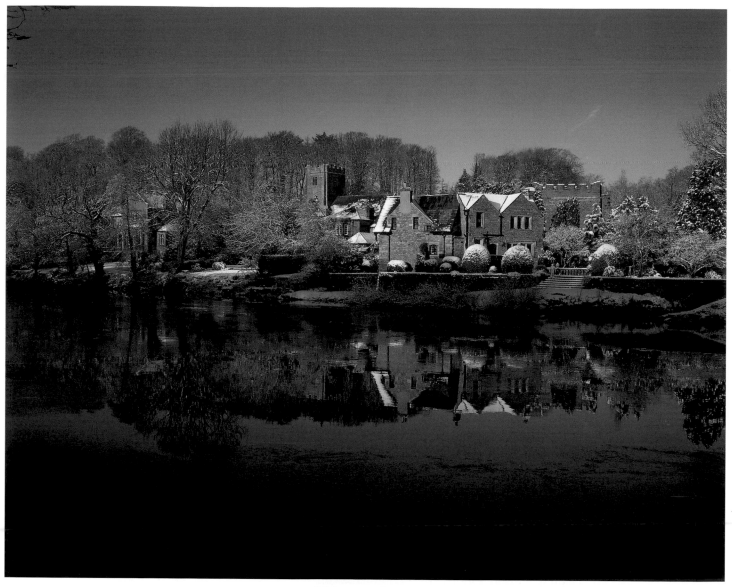

Halton-on-Lune
A crisp winter's day, with the River Lune partially frozen. The tower of St Wilfrid's church is
on the left of the picture. This view is seen from the foot and cycle path which runs alongside
the River Lune from Lancaster, past Halton, to Crook O'Lune and Caton.

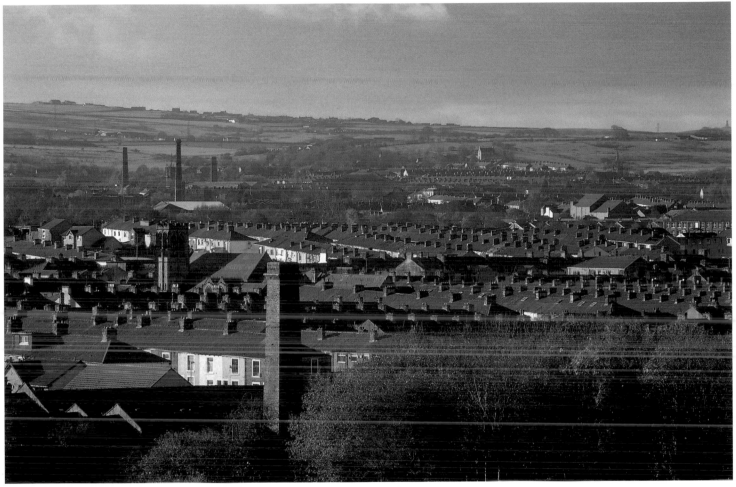

Accrington roofscape
This landscape of terraced houses and factory chimneys is probably what many unenlightened
Southerners think of as typically Lancashire. But it's actually quite hard nowadays to find a really
good example to photograph – and even here, there are green fields on the horizon.

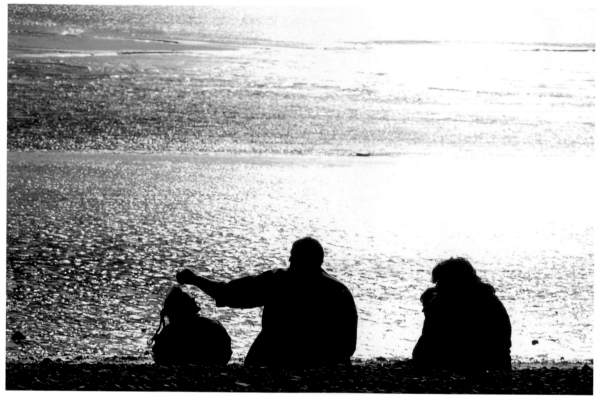

On the beach, Morecambe Bay
It happens to be Morecambe, but it could as easily be Blackpool,
or almost anywhere along the Lancashire coast.

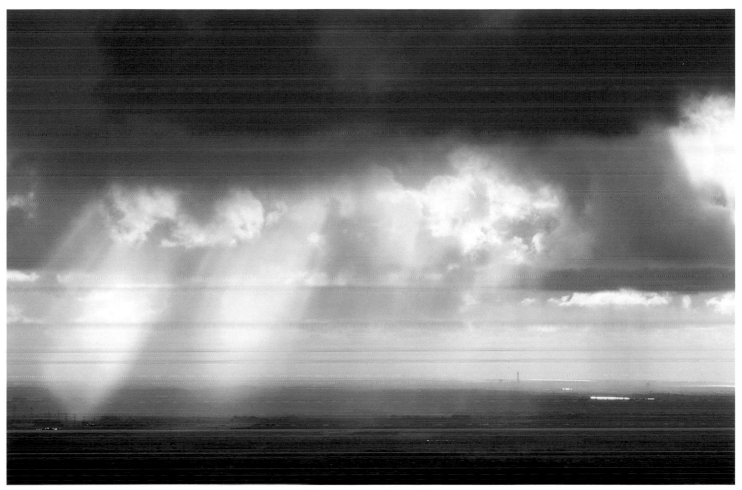

Showers over the Fylde
This view gives a good impression of the flatness of the Fylde, and indeed
most of western Lancashire. It also helps to explain why Blackpool Tower –
right of centre – is such a prominent landmark from so many viewpoints.

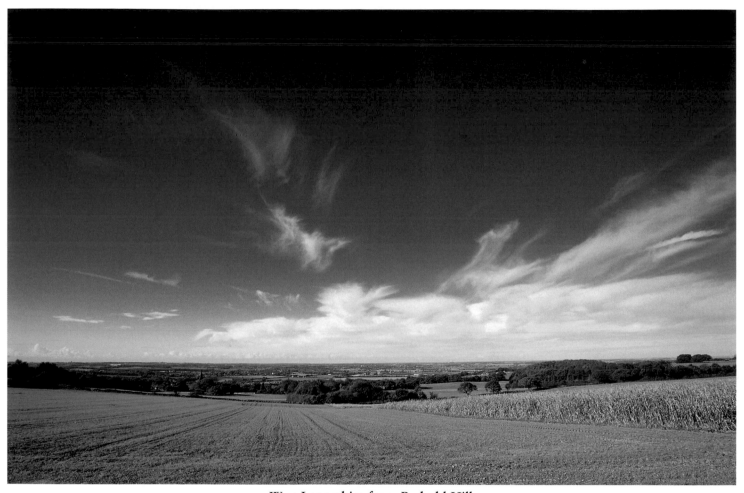

West Lancashire from Parbold Hill
This view is taken from the footpath between High Moor and Parbold Beacon,
looking out over Parbold village to Burscough and Ormskirk with the coast beyond.
The flatness and low altitude of western Lancashire is once again evident.

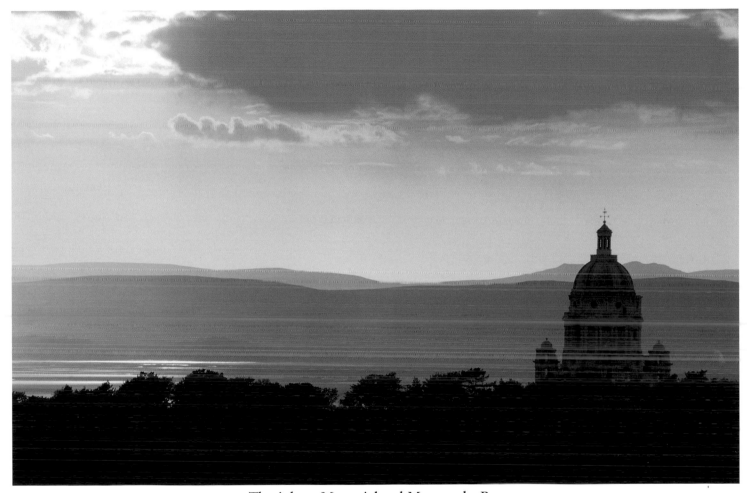

The Ashton Memorial and Morecambe Bay
To travellers on the M6, Lancaster's Ashton Memorial is a familiar, if sometimes puzzling sight.
But you need to leave the motorway and climb up the ridge to the east to see it against
the backdrop of Morecambe Bay and the Duddon fells.

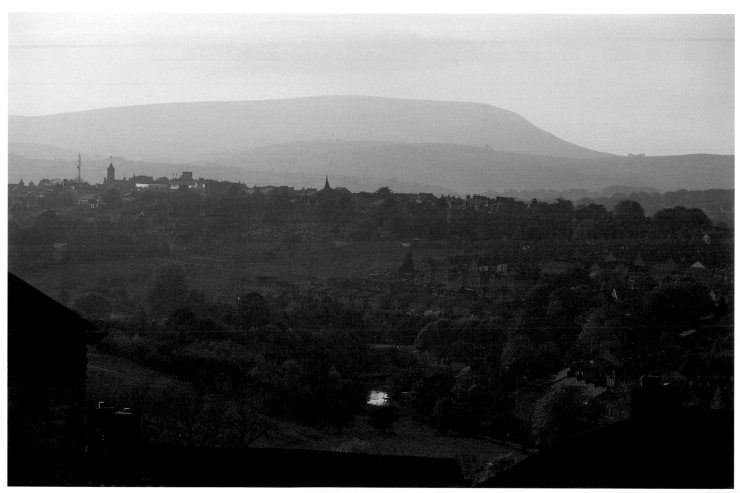

Colne and Pendle Hill from above Laneshaw Bridge
Pendle Hill is not the highest hill in Lancashire, but more people could name it than either
the true highest point (Crag Hill, on the border) or the highest hill entirely in Lancashire
(Ward's Stone). Its central position and separation from other high ground give it prominence,
and its closeness to towns like Burnley, Nelson and Colne makes it very popular.

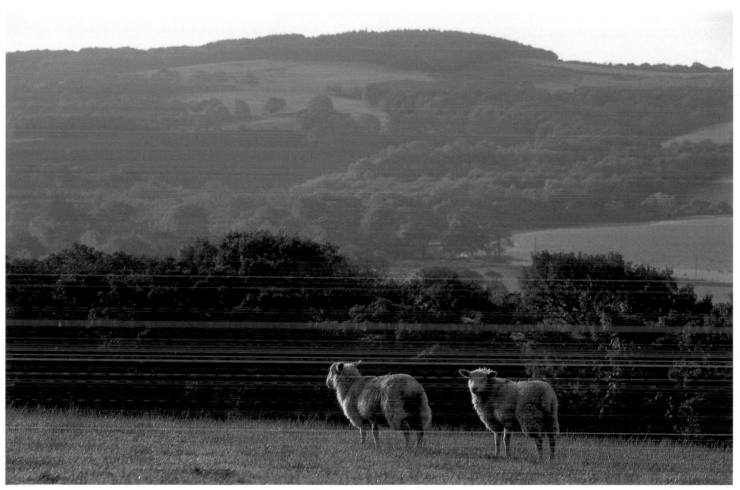

Sheep, near Parbold
This shot was taken above the Douglas valley, looking across to Ashurst's Beacon

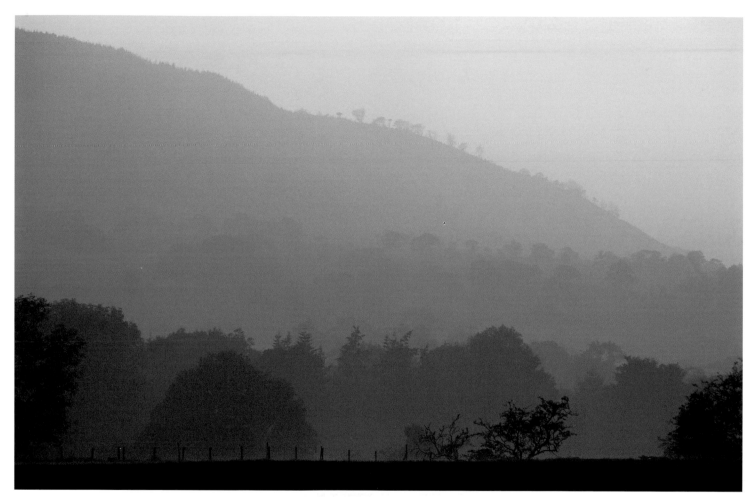

Longridge Fell from Bashall Eaves
I'd passed this spot numerous times but never stopped, until a
gloriously misty evening meant that I just had to.

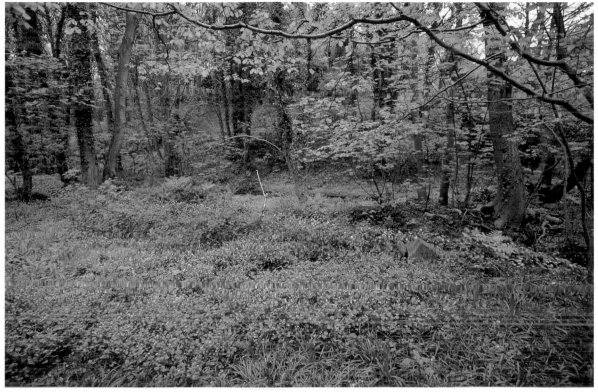

Enchanter's Nightshade, Fairy Glen
On my first visit, Fairy Glen was full of wild flowers. I could name a lot
of them but didn't know what this little pinkish-white one was. It seemed
eerily appropriate later when I identified it as enchanter's nightshade.

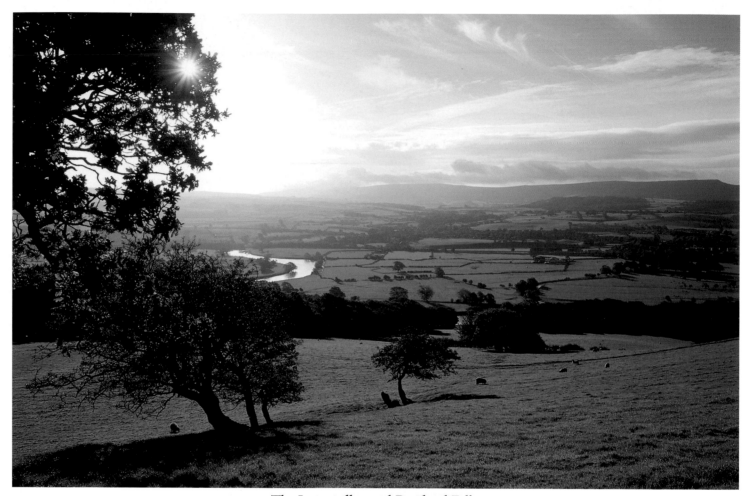

The Lune valley and Bowland Fells
Beyond the flood-plain and meandering river, the ground rises to the Bowland
Fells. The stepped summit is Clougha Pike and the higher but more distant
Ward's Stone is roughly in the centre of the picture.

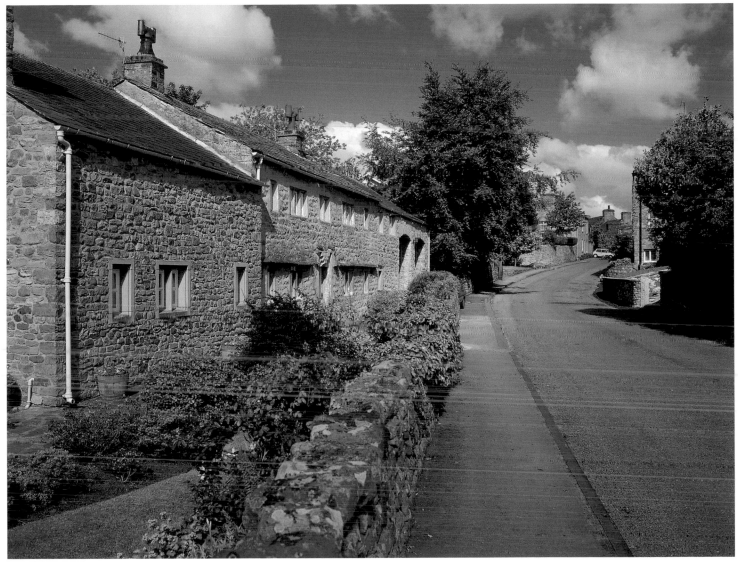

Arkholme

Arkholme's main street runs down towards the river and through traffic now passes it by, leaving
it remarkably peaceful. At the river end of the street the little church of St John the Baptist stands
on an ancient mound, and just below it there is easy access to the river bank.

Witton Park, near Blackburn
Witton Country Park was formerly the estate of the now demolished Witton House.
It covers almost 200 hectares (about 480 acres), criss-crossed by paths and nature
trails, and rises to 245 metres (803 ft) on Billinge Hill, the scene of this shot.

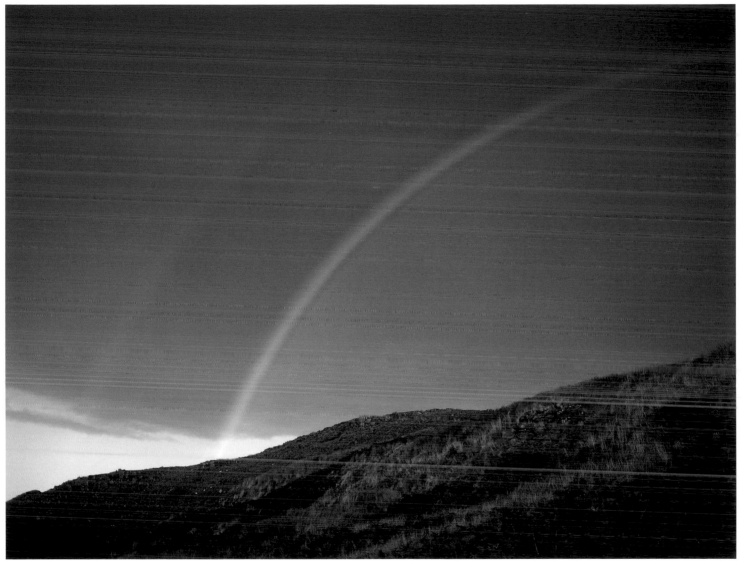

Rainbow over Clougha Pike
Rainbows are one of the most fickle of subjects and often you have to take what you can get. But
this double bow over the craggy flanks of Clougha Pike at least gave me time to set up the tripod.

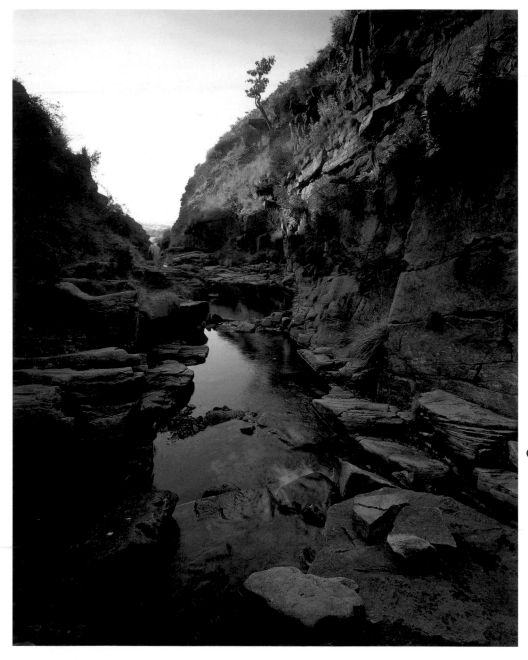

Dean Black Brook
Dean Black Brook cuts through the edge of the moors above White Coppice. I was expecting to wander further onto the moors in search of a broad view but instead found myself lured – perhaps the word is seduced – through an old quarry into this secretive ravine or clough, as it would usually be called in Lancashire.

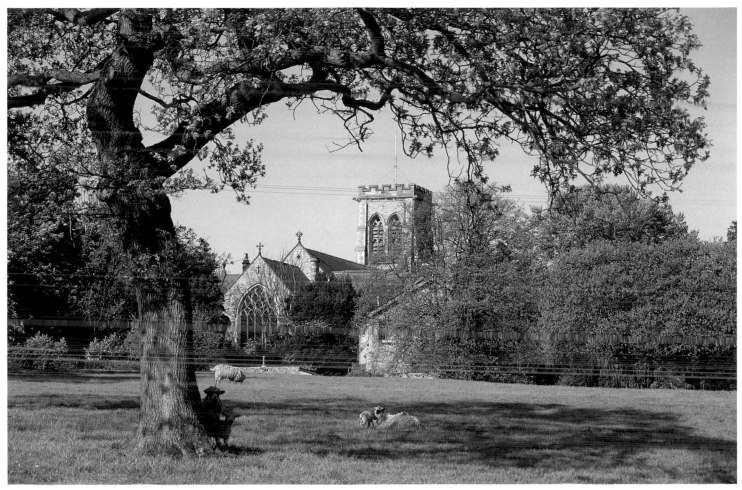

Silverdale church
Arnside-Silverdale is the second smallest of the country's 41 Areas of Outstanding
Natural Beauty (AONBs) but still a rich mix of coast, wetland, woodland, farmland
and limestone crags, with a great diversity of wildlife. There are few places where
even a short walk can be as varied or as rewarding.

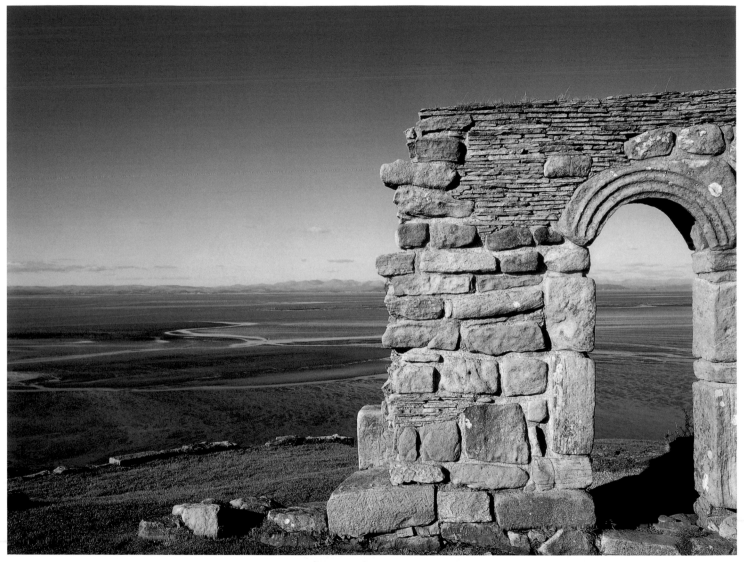

Morecambe Bay from Heysham Head
The ruins of a tiny chapel are said to mark the spot where St Patrick first set foot in England. Only a cynic would point out that, as the chapel stands above cliffs, it must have been a miraculously high tide that day. Beyond is Morecambe Bay, where the low tide reveals mile after mile of sand and mud banks.

Singleton
On my first visit to Singleton, it seemed almost deserted, and the whole village had a time-warped feel about it: I imagined I had stumbled into a Miss Marple setting. On subsequent visits there always seems to be a little more traffic about, but traces of that atmosphere remain

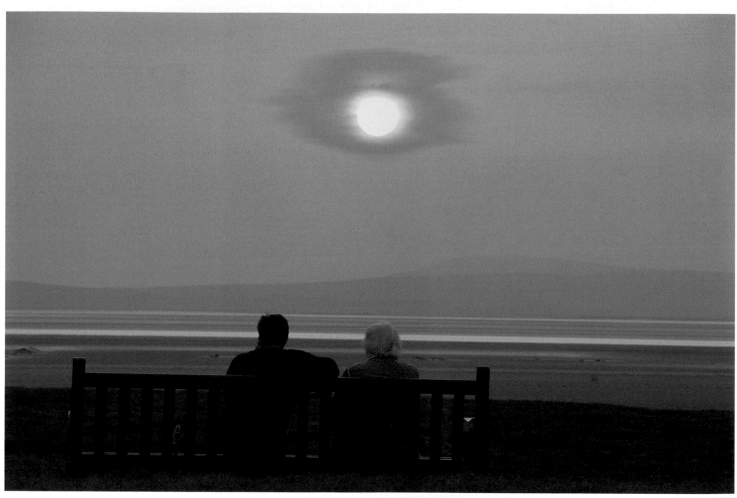

Watching the sunset, Hest Bank
Watching the sunset is a popular occupation on the Lancashire coast. I've always
appreciated the fact that we're on the west coast as I'm not good at getting up early
and so I'm much better at sunsets than sunrises.

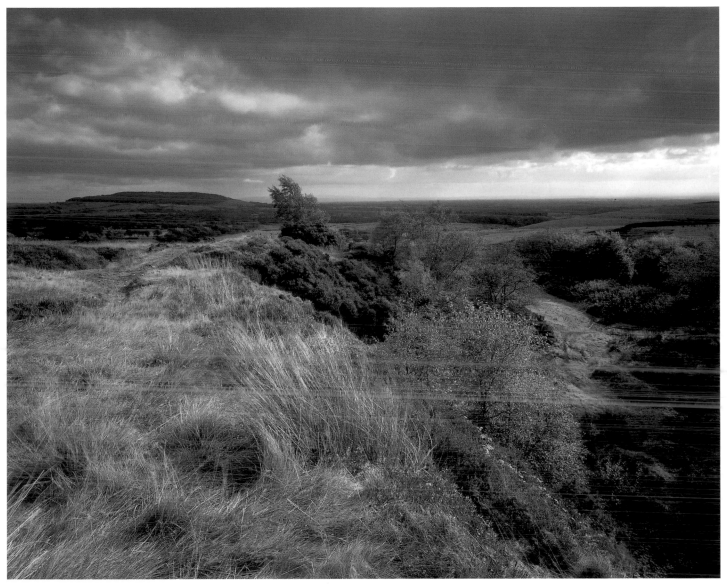

Delph Quarry and Beacon Fell
Delph is a common element in Lancashire place-names and means 'quarry' or 'digging'
– so calling it Delph Quarry is really tautology. The West Pennine moors rise on the
distant skyline, with Preston a little nearer and further to the right.

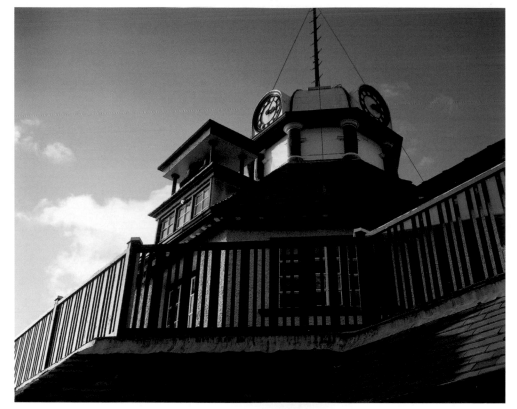

The Mount, Fleetwood
Fleetwood was a pioneering 'new town', planned by architect
Decimus Burton at the behest of Sir Peter Hesketh. The hill known
as The Mount, which is partly artificial, became a focal point.
Families would gather here to watch for the safe return of the
fishing vessels. The pavilion on its summit was built in 1902.

Wycoller Beck
Wycoller can be a busy place, but visitors are not allowed to bring their cars into the village
– a measure which a few other places would do well to copy – so it generally retains a
peaceful atmosphere. Those who walk up the valley a little further will find even less
disturbance and the scene seems to lend itself to contemplation.

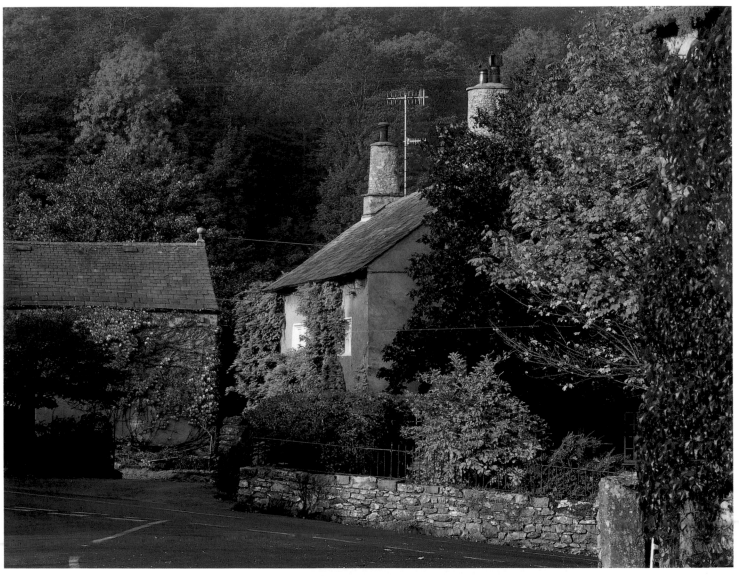

Yealand Conyers
Lancashire is richly supplied with attractive villages. Yealand Conyers and
nearby Yealand Redmayne are relatively unsung examples, but in less
fortunate counties they would surely receive much more attention.

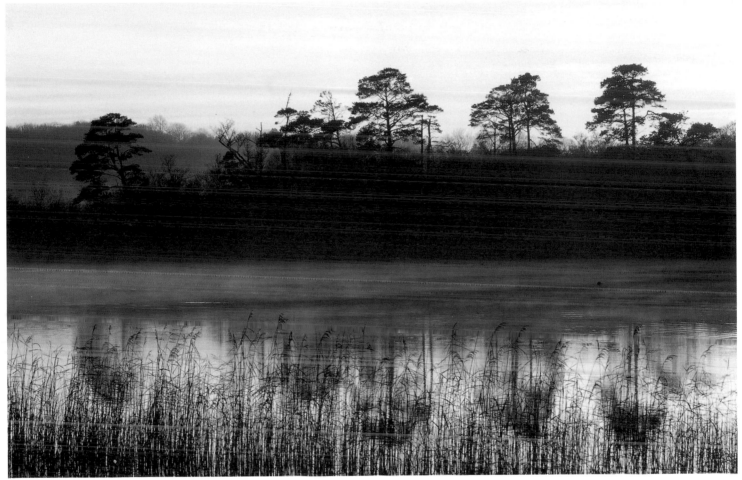

Hawes Water
Hawes Water (not to be confused with the much larger lake of the same name in Cumbria) lies near Silverdale. It's surprising to find such a substantial tarn in an area of permeable limestone: it owes its existence to a bed of glacial clay.

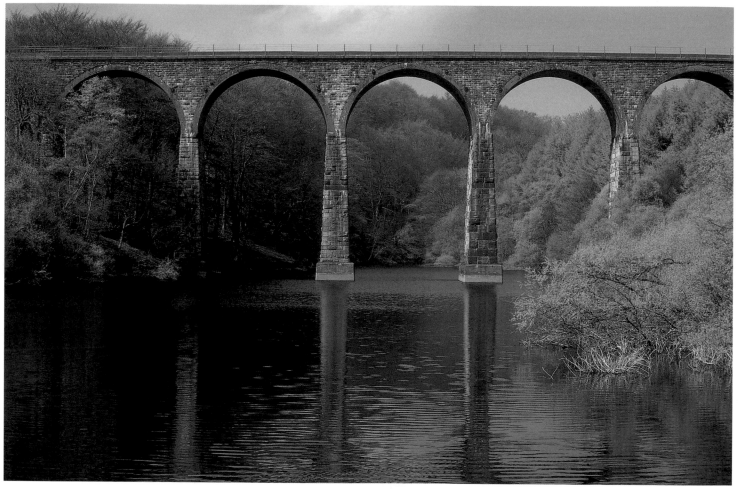

Viaduct, Wayoh Reservoir
The well-watered West Pennine uplands are ringed with reservoirs constructed to
supply water to nearby towns and cities, but have also become valuable amenities
for the population and often important wildlife havens too. Around 150 bird
species have been sighted in the vicinity of Wayoh reservoir.

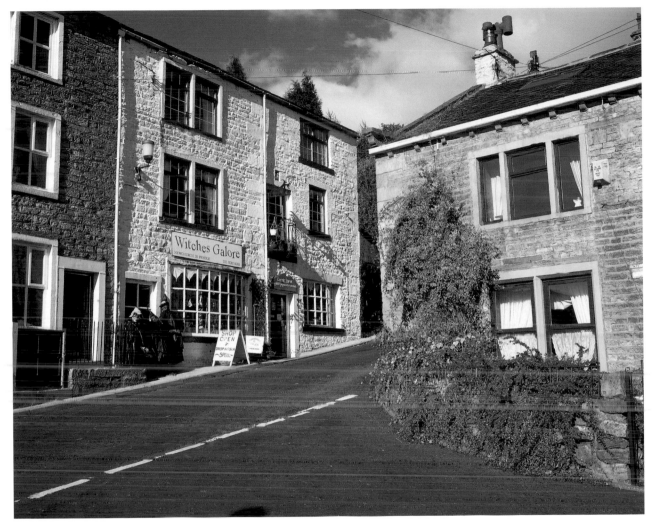

Newchurch-in-Pendle

The small village of Newchurch-in-Pendle, on the flanks of Pendle Hill, plays a central role in the story of the Pendle Witches. In 1612 seven women and two men from the area were tried and hanged at Lancaster Castle. Some of them had actually confessed to the practise of witch-craft, but of course we know today that under sufficient pressure many people will confess to crimes they have not committed. It is hardly possible now to say whether any of the accused were 'genuine' witches – whatever that might mean. The 'new' church which gives the village its name was already well-established, having been founded in 1544.

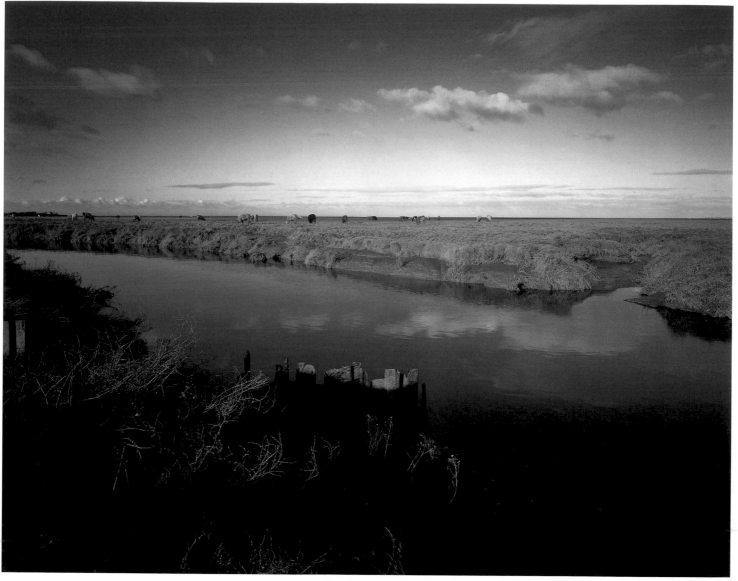

Banks Marsh
Banks Marsh is an expanse of salt-marsh on the southern shore
of the Ribble estuary, riddled with tidal creeks.

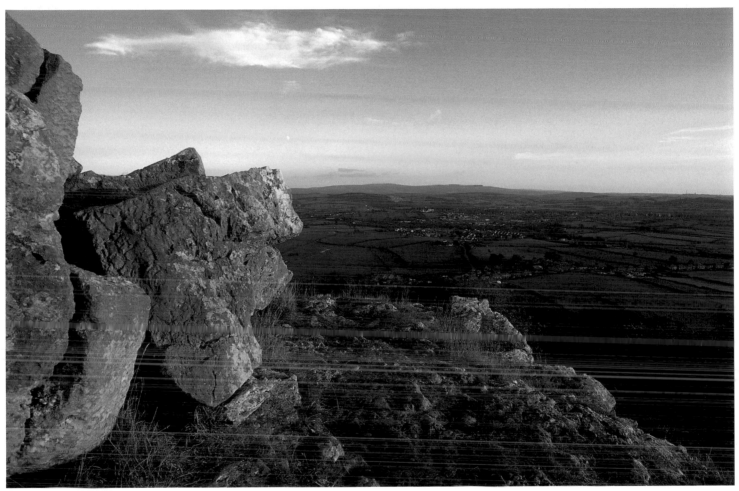

Warton Crag and Carnforth
Carnforth is seen from Warton Crag, with Clougha Pike and the Bowland Fells
on the skyline and, much further right, Lancaster's Ashton Memorial.

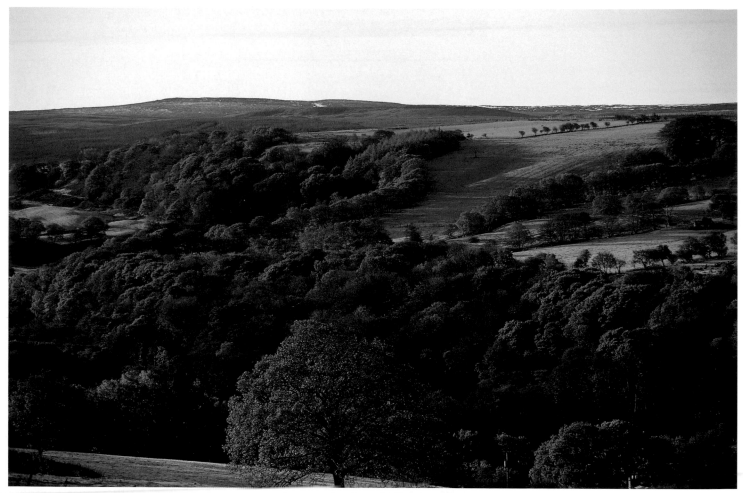

Autumn in the Hindburn valley
Not to be confused with Hyndburn, the area around Accrington, the little River Hindburn
descends from the northern side of the Bowland Fells. It is no more than 15 kilometres (9 miles)
long, but a lot of high moorland drains into it and it can be fierce after heavy rain, the 1967
floods which devastated the village of Wray being a recent instance.

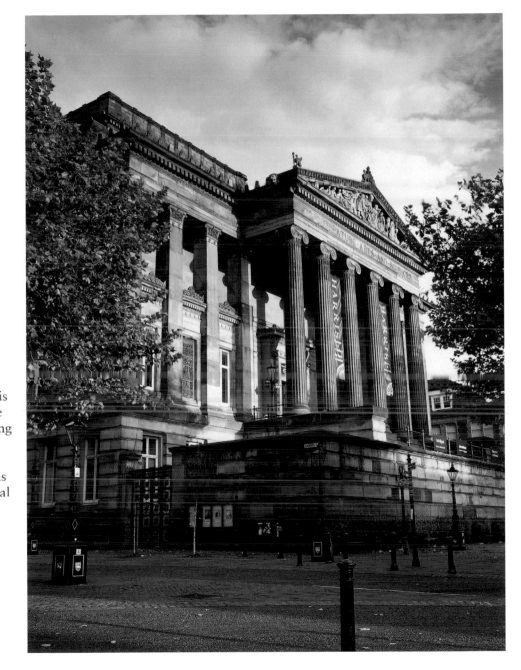

The Harris Museum and Art Gallery, Preston
Usually called simply 'the Harris', this Grade 1 listed building stands in the heart of Preston. It was built following a bequest by the wealthy solicitor Edmund Harris. The building now houses major art and craft collections along with the 'Story of Preston' social history gallery. Admission is free. Another bequest created the Harris Institute, distant ancestor of today's University of Central Lancashire.

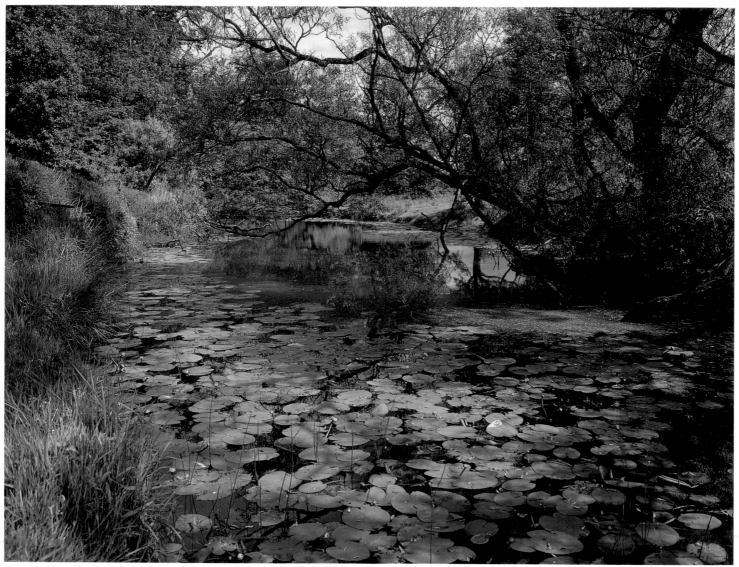

Backwater near Higher Broomfield
This scene is just a short stroll from Arkholme, in the heart of the Lune valley. The River Lune rises
in the Howgill Fells in Cumbria, and reaches the sea a few miles south of Lancaster. The section
between Lancaster and Kirkby Lonsdale has fine pastoral scenery with good footpaths allowing the
riverbank to be followed almost the whole way: a great walk for a fine summer's day.

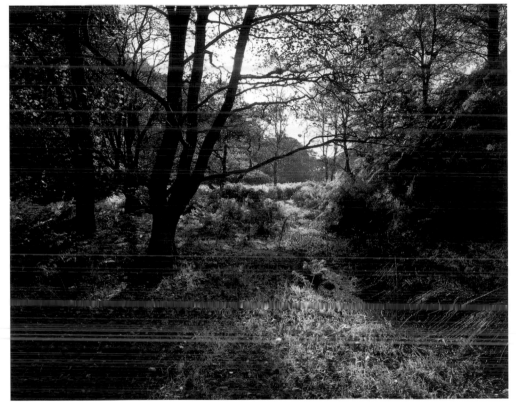

Grizedale
This little valley lies near Scorton, north of Garstang. It's deservedly
popular with local people but little known further afield.

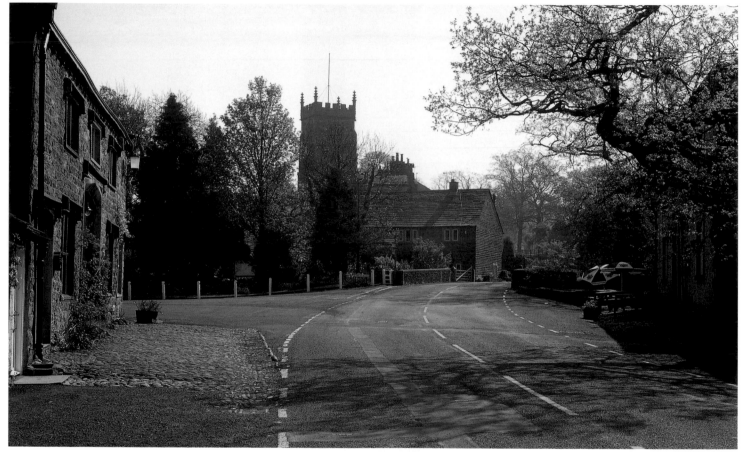

Bolton-by-Bowland
Bolton-by-Bowland, in the Ribble valley, is a well-preserved village
and has the unusual distinction of having two village greens

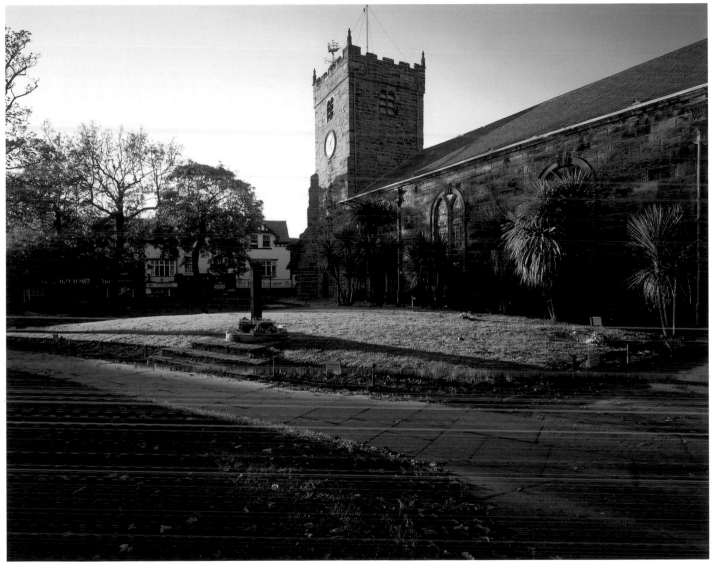

Poulton-le-Fylde
Poulton is an ancient market town. These days it is usually described as being 'near Blackpool'
but it hasn't always played second fiddle. Before the railways brough mass tourism to the coast,
Poulton was the main centre in the northern Fylde. The streets immediately surrounding St
Chad's church still retain a flavour of those times.

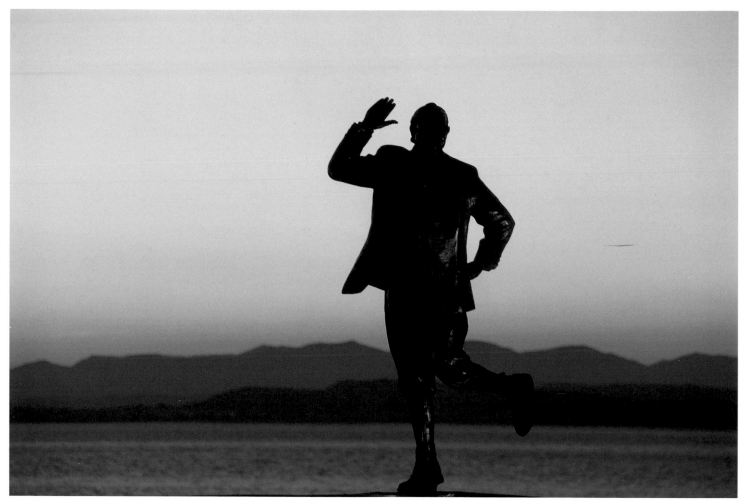

Eric Morecambe statue, Morecambe Promenade
Eric Morecambe died in 1984 but is still fondly remembered by millions. In their time
Morecambe and Wise were undisputedly Britain's top comedy act. Born Eric Bartholomew,
Eric took his stage name from the town of his birth. This statue by Graham Ibbeson was
unveiled by the Queen in July 1999 and has been immensely popular ever since. The binoculars
commemorate Eric's love of bird-watching, for which Morecambe Bay is a wonderful site.